T0102293

DEGAS

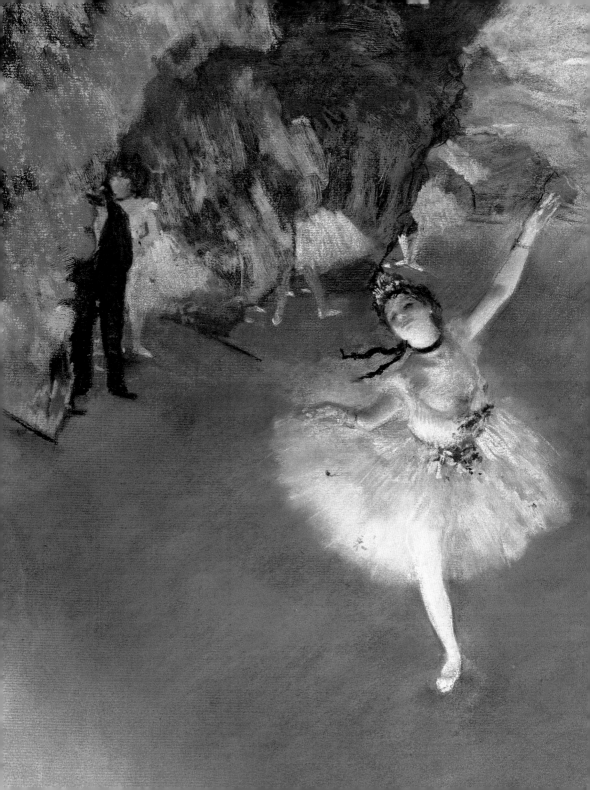

MASTERS OF ART

DEGAS

Alexander Adams

PRESTEL
Munich · London · New York

Front Cover: Edgar Degas, Dancers at the Barre, c. 1900

© Prestel Verlag, Munich · London · New York, 2022,
A member of Penguin Random House Verlagsgruppe GmbH
Neumarkter Strasse 28 · 81673 Munich

In respect to links in the book, the Publisher expressly notes that
no illegal content was discernible on the linked sites at the time
the links were created. The Publisher has no influence at all over
the current and future design, content or authorship of the linked
sites. For this reason Penguin Random House Verlagsgruppe
expressly disassociates itself from all content on linked sites that
has been altered since the link was created and assumes no
liability for such content.

A CIP catalogue record for this book is available from the British
Library.

Editorial direction Prestel: Nora Schröder
Copyediting: Vanessa Magson-Mann, So to Speak
Production management: Andrea Cobré
Design and layout: Florian Frohnholzer, Sofarobotnik
Typesetting: ew print & medien service gmbh
Printing and binding: Litotipografia Alcione, Lavis
Typeface: Cera Pro
Paper: 150g Profisilk

Penguin Random House Verlagsgruppe FSC® N001967

Printed in Italy

ISBN 978-3-7913-8736-9

www.prestel.com

CONTENTS

INTRODUCTION

The art of Edgar Degas is as controversial as ever. That might seem a peculiar assertion, after all, one cannot visit a poster shop or a picture framer without encountering Degas's ballet-dancer pictures. Degas's depictions of dancers are considered the epitome of glamour and panache. They distill the sophistication of *belle époque* Paris, its great civilisation and history-changing culture at its height, into classic art. Yet the ballet pictures have been decried as fantasies served up to the complacent bourgeoisie. On the other hand, they have also been acclaimed as exposés of harsh conditions experienced by young working-class women. Likewise, scenes of bathers have been criticised as lewd and cruel, but they were also loved by many women who considered them to be honest representations of their lives. This division also applies to Degas's personal conduct. Was Degas a hater of Jews and women or a sensitive man, capable of kindness, cut adrift in a time of social turmoil? Perhaps he was both. How can we reconcile reports of his caustic aspersions regarding women and his unstinting support for the painter Mary Cassatt? And all this time we are irresistibly drawn back to Degas's art because of its human insight, technical élan and profound startling beauty.

Such conflicting strong reactions can be found during Degas's lifetime. While detractors of Degas's art were never as vocal or widespread as those of the art of Courbet and Manet—though often Degas was classed alongside these realists—his art was considered shocking by those concerned with decorum. Degas's depictions of women washing seemed indecent to some; others were aghast at abrupt truncations of the human form and the rough finish of the pictures. On multiple levels, his art flew in the face of good taste. Avant-garde artists of a younger generation—such as Paul Gauguin, Walter Sickert, Edvard Munch and Pierre Bonnard—revered him.

If one were inventing an artist composed of contradictions then one could not surpass the truth of Degas. He was obsessed by the Old Masters yet turned away from the grand subjects of art. He was an acute observer of human behaviour yet was primarily solitary. He was an advocate of Realism who eventually rejected that genre to push art to the limits of abstraction. He was one of the greatest of portrait painters who repeatedly concealed the faces of figures. He was a classically gifted draughtsman who broke every rule of good practice in his use of materials. This painter's most famous work is a sculpture—the only one he ever exhibited. He

spent much of his working life on sculptures that he allowed to crumble to dust. He was from a family with aristocratic pretensions yet he passed his days with the very poorest labourers and outcasts of Paris. Bitterly envious, he also helped colleagues by collecting and promoting their art. Deeply loyal, he allowed politics to tear him apart from friends. He was intensely proud and private. We know nothing about his romantic life.

In this book we will look at some contemporary reactions to Degas's most famous pictures and learn about how people perceived them when they were new. Background research throws a new light on familiar pictures, revealing them as more complex than they at first appear. We shall find Degas as a devoted student of classical art and as a vital force behind the organisation of the ground-breaking Impressionist exhibitions. We shall watch him abandon fields in which he was supremely gifted such as portraiture and interiors, while failing to exploit areas, such as sculpture, which he had practically mastered, and we will see him return repeatedly to his greatest love: the human figure. Most of all, we will enjoy his rich and splendid art.

We can still experience the excitement of his art. Degas's colour combinations and technical flexibility are as radical as anything in art before or since. He reinvented how the human body could be portrayed. Never before had the figure been seen so unguardedly; in his pictures of nudes we encounter the body in ways that are unconventional, indeed sometimes ugly, and often alluring. Although much of what Degas depicted was specific to his city and people he knew, we can relate to his art without explanation. Indeed, Degas's art relies on the visual without narrative or background information, which is one of the reasons it has sustained its popularity. This selection of pictures and associated commentary is an attempt to present the case that Degas was not only the most gifted painter of the human figure but perhaps the greatest of all artists.

LIFE

On 19 July 1834, Hilaire-Germain-Edgar De Gas was born in Paris to parents Auguste De Gas (1807–1874), from a Naples banking family, and Célestine Musson (1816–1847), a Franco-American from New Orleans. Edgar was thirteen when his mother died. Auguste was a banker who had a passion for music. He wanted his son to study law but in 1855 Edgar—who later took to spelling his surname "Degas"—met the Neoclassical painter J. A. D. Ingres (1780–1867) and subsequently decided to pursue his passion for art. Edgar persuaded his father to allow him to enroll at the École des Beaux-Arts in April 1855.

Degas was captivated by classic art from antiquity up to his own time and was more committed to copying at the Louvre than to studying at the École. His preferences were for Italian art: Giovanni Bellini, Donatello, Mantegna, Raphael, Titian. He broke off formal education to study alone in Italy. By this period, the grand tour of Italy, including stays in Rome, Naples, Florence and Venice, was falling out of fashion. Just as French painters were looking to Holland, Spain and England, Degas decided to go to the source of classicism. Not coincidentally, Degas spoke Italian and had family with whom he could stay.

In July 1856, Degas travelled to Italy. Financially supported by his father, Degas stayed with relatives in Naples. He recalled these as the happiest days of his life. He painted portraits and self-portraits, visited museums and dilligently copied art. Over 700 copies in all media by Degas are extant today. While in Florence, Degas began studies for a group portrait of the Bellelli family,

which became his first great achievement. In Rome in 1858 Degas met his fellow Frenchman Gustave Moreau (1826–1898), who was nine years older and already an established History painter. Later, Moreau would become a leading figure in the Symbolist movement and Degas would develop a dislike for his art, but in Rome they were friendly companions, copying together and drawing life models at the Villa Medici school for French artists.

In Italy, Degas learned how to make etchings by drawing into a wax-coated metal plate. He learned the aquatint method of creating speckled shading on etching plates and applied this to etched copies and original compositions in the style of Rembrandt. He produced meticulously fine printed portraits and self-portraits (page 11). Yet no sooner had he mastered the technique, he lost his enthusiasm for it. Aside from some etchings of Manet in 1864/5, Degas practically gave up the medium.

By 5 April 1859, Degas was back in Paris, planning to make his artistic entrance, yet he did not exhibit at the Paris Salon until May 1865. What delayed his debut?

The Paris Salon was an annual open-submission exhibition selected by jury. It was the most visited public display of visual art of the era. Degas was dogged by his own procrastination—he was always criticised as a perfectionist. Additionally, the essential obstacle Degas had to overcome was his preconception of what subjects he should tackle. In these early years, Degas was severely constricted by his aspirations to depict

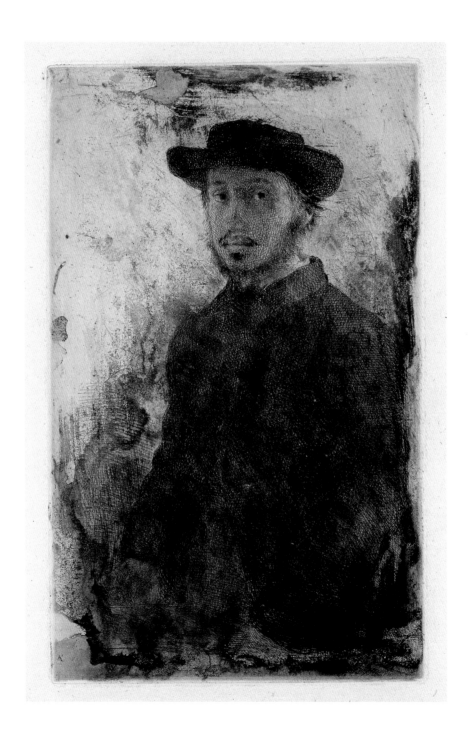

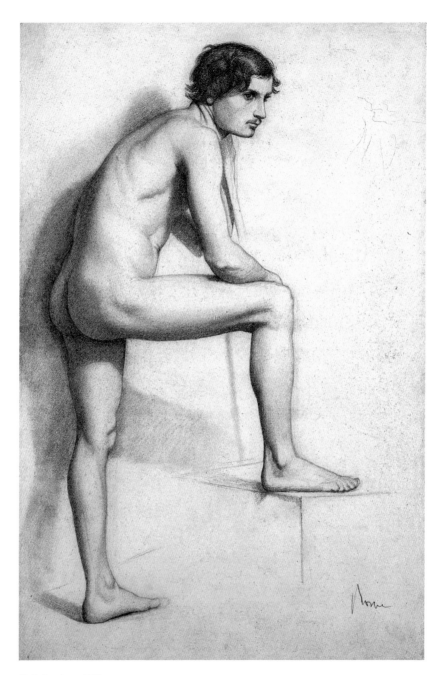

Nude Study, c. 1858

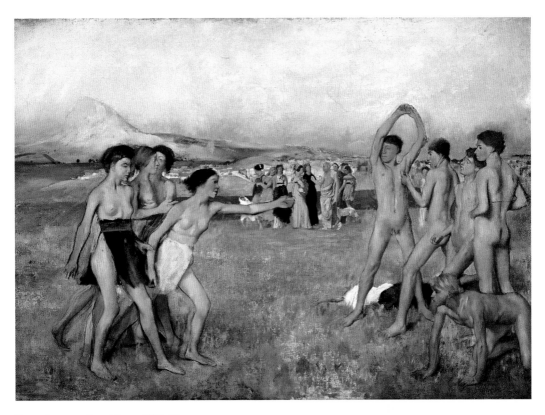

Young Spartans Exercising, c. 1860–62

the glories of the history of France and ancient literature. He was attached to the ideal of History painting that was already outdated and largely discredited. Realism had swept up many of the most advanced painters, causing a rift in French art. One side was led by Gustave Courbet (1819–1877), who followed the innovations of Jean-François Millet (1814–1875). Courbet's Salon contributions of 1850 had consisted of realistic scenes of rural life; they had revolutionised expectations of what art should do. The other side was headed by academic painters Ernest Meissonier (1815–1891) and William-Adolphe

Bouguereau (1825–1905), who painted military and mythological pictures. Peculiar as it seems to us in retrospect, Degas was painting his powerful, psychologically perceptive portrait of the Bellellis, while also painstakingly preparing the stiff and archaic History paintings that he believed would win him fame.

An early History painting was of Spartan girls attempting to distract Spartan boys from their martial preparation. As this painting evolved, Degas decided to remove most of the classically draped figures and a temple in the background, realising that the classical references detracted

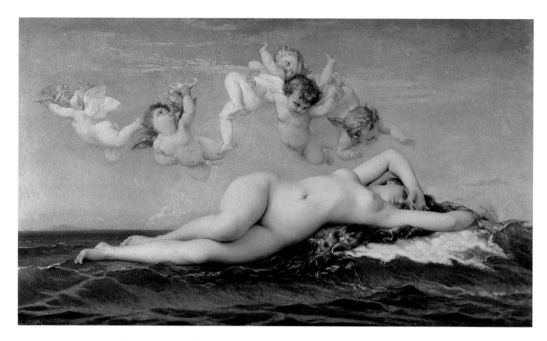

Alexandre Cabanel, *The Birth of Venus*, 1863

from the encounter in the foreground. The result is an unresolved hybrid. It displays the genesis of Degas's later bathers and dancers, and showcases an ability to paint anatomy and body language, but the setting is vague and the subject muddled. Paintings on other historical and Biblical subjects proved impossible for Degas to carry out satisfactorily.

The first painting by Degas to be accepted for the Paris Salon was *A Scene of War in the Middle Ages* (1865). In this gloomy painting, medieval archers on horseback shoot naked women in a country lane. The pencil studies of the nudes are exquisite but the painting is nonsensical; none of its viewers could determine what the source was.

Therefore it failed as a History painting by lacking an explicable moral message that was a prerequisite for any History painting. The muted public response to this painting, a growing appreciation of Realism and his friendship with Édouard Manet (1832–1883) led to Degas accepting that History painting—at least in its conventional sense—was an exhausted genre.

The companionship and inspiration of Manet cleared Degas's head. Manet showed that it was possible to produce art about modern urban life which also referred to great art of the past. He made paintings that quoted famous ones by Giorgione, Raphael and Veláquez and used the technique of Rembrandt and Hals, yet

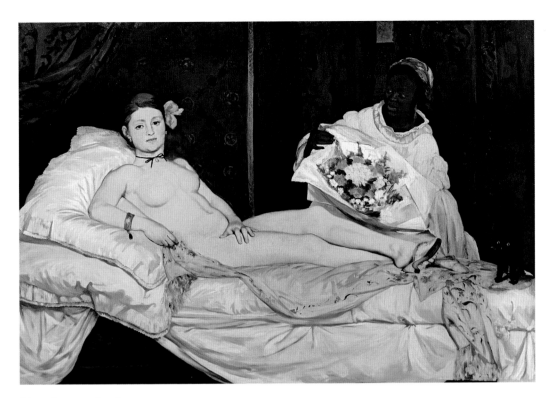

Édouard Manet, *Olympia*, 1863

Manet never claimed to be anything other than a Parisian of his own era. When Alexandre Cabanel exhibited an academic painting *The Birth of Venus* (1863), it was acclaimed by critics and purchased by Emperor Napoleon III for his private collection. When Manet exhibited *Olympia* (1863), it outraged critics and had to be protected from physical attack in the gallery. For an artist who admired the past but saw no future in academic painting that had become sterile and hollow, Manet's path was an ideal alternative for Degas. Degas eventually moved beyond Manet's realism with his later nudes, such as *Bather Lying on the Ground* (1886–88). With naturalistic description, broken surfaces and optical complexity, Degas went further than Manet by dematerialising and reconstituting what he was representing. Manet never explored fully the capacity of paint to be paint, as well as being a means to describe a person or a flower. Cabanel was an idealist; Manet was a realist; Degas was a materialist.

It was in 1865—only two years after Charles Baudelaire had challenged artists to become the "painter of modern life" in his eponymous essay, published in the daily newspaper *Le Figaro*—that Degas turned from History painting to portraiture and interiors, executed in a realistic manner, dark in tonality. The subjects were fellow artists, family members and acquaintances. He made a touching portrait of his father lost in contemplation,

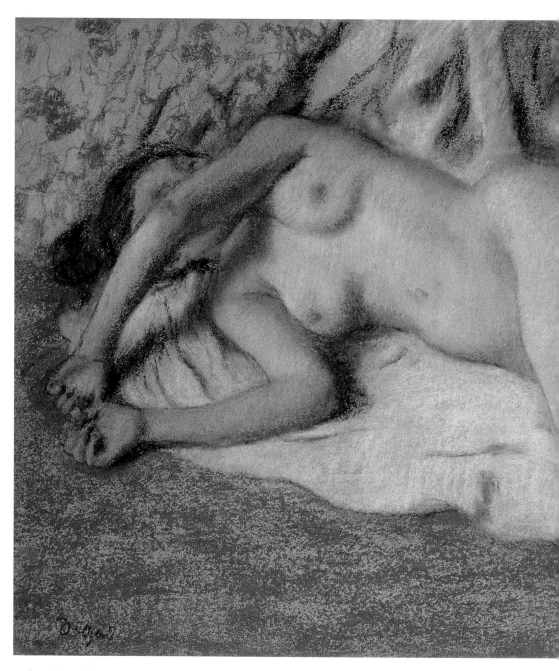

Bather Lying on the Ground, 1886–88

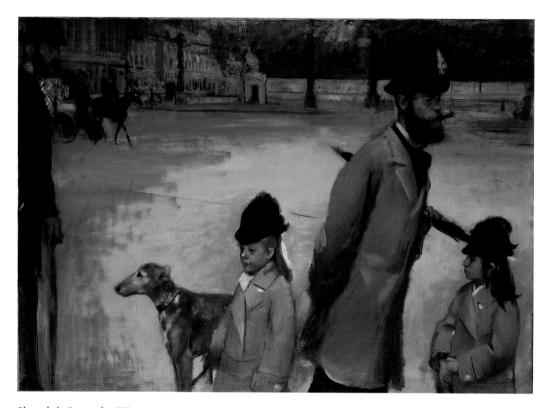

Place de la Concorde, 1875

listening to the guitarist Pagans. He made portraits of Manet, including a double painting of him listening to Madame Manet playing piano, which he then gave to Manet. Manet cut out the part with his wife and kept the part of himself. Degas forgave him.

Degas excelled in portraiture. Not only was he an accurate draughtsman, he was also observant regarding the personality of those he encountered. As early as his portrait of the Bellelli family, Degas shook off the standard approach to portraiture. His portraits often position sitters off-centre or off-balance. In group or pair portraits, sitters frequently fail to interact with each

other in the expected manner. They display boredom or lack of engagement; sometimes they are anxious or distracted. Psychological intensity in fine art was not invented by Degas but his reading of body language and facial expression are heightened and particularised in a way that make his insights equivalent to the discoveries of Freud in psychology and psychiatry.

Degas made his first paintings of the racetrack at Longchamp, Paris in 1866. He drew horses on the estate of the Valpinçon family. He turned his attention also to café scenes, with subjects ranging from well-known actresses and singers to anonymous drinkers. In both areas, Degas was

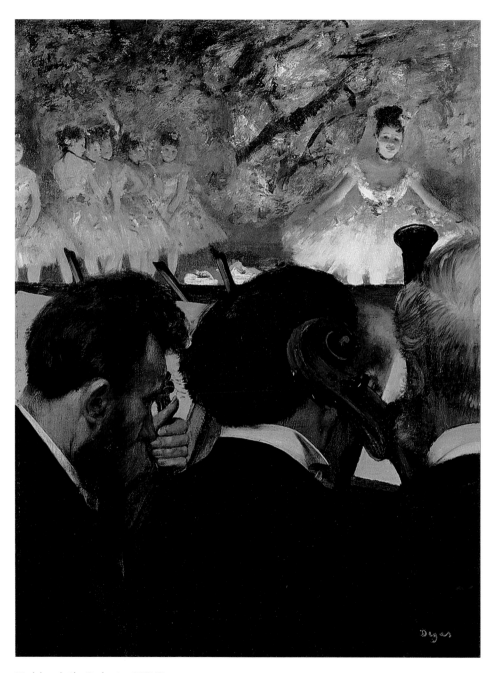

Musicians in the Orchestra, 1872–76

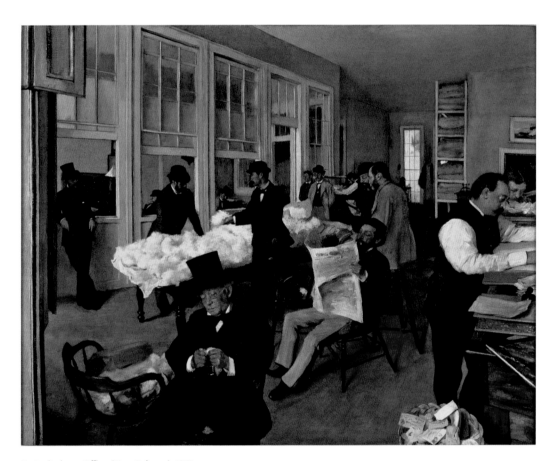

Portraits in an Office (New Orleans), 1873

following Manet's lead. Degas's views of musicians and orchestras derived from his family's love of music and frequent attendance at performances. Degas prepared his paintings carefully, making individual portraits of musicians, drawing instruments and chairs and so forth. New topics of café-concerts and views of the ballet allowed Degas to play with binaries: dark audience, bright performer; male viewer, female subject; active and passive. Paintings such as *Musicians in the Orchestra* (1872–76) are period and style thresholds. The dark, realistic male musicians come from the 1850s and 1860s; the light, vigorously painted female performers are precursors of the late 1870s and after. This interpretation is complicated by the fact that Degas returned to this particular painting and revised it. We might simply be witnessing the artist working during two stages in his career.

The subjects of theatre-café and café-cabaret are vividly artificial, with performers providing spectacles of colour, light, gesture, costume and setting. These subjects were very popular and taken up by a number of artists. The triple themes of cafés, cabaret performers and the ballet overlap, and Degas shifts focus between performers, practice and audience in each picture. A handful of events interrupted the artist's development at this crucial period.

His progress was briefly disrupted by the Franco-Prussian war (1870/1) and subsequent Paris Commune. Degas, like many artists, served in the defence of Paris. Some artists died in combat (notably Frédéric Bazille and Henri Regnault)

but Degas did not fight before the fall of France. His service was a matter of pride for him; he would reminisce about it years afterwards. At that time, army doctors identified a weakness in Degas's eyesight, a condition that would worsen with age.

From October 1872 to March 1873, Degas made an extended visit to New Orleans, staying with his family. Degas's brothers René and Achille worked with their uncle Michel Musson in a cotton export company. Degas prepared a picture of their office, which he would paint back in Paris. Degas wrote effusive letters to friends, describing the climate and people of New Orleans. Upon the artist's return to Paris, Degas executed his New Orleans painting, which made a good impression and was purchased by a French museum in 1878.

Aside from making portraits, Degas's engagement with the performing arts determined the art he made following his return to Paris. Just before his American sojourn, Degas sold work to Paul Durand-Ruel, who would become his principal art dealer for the rest of his career, providing the artist with some stability. Durand-Ruel's first purchase was a scene of the orchestra. The need to exhibit and sell became pressing in 1874 when the Degas family was nearly ruined financially.

In 1875 the Paris Opéra relocated to a new building. We have information that between 1885 and 1892, Degas visited the Opéra 177 times, less frequently towards the end. He attended opera and ballet performances, drawing in the practice room and sketching performances and rehearsals

on stage. He made portraits of musicians, dancers, actresses and singers, ranging from casual sketchbook sketches to elaborate oil paintings. Over time, Degas concentrated more on the dancers than the musicians. For performances, Degas chose very high or very low vantage points; he also would draw from the wings. This tended to produce compositions that were unusually dramatic, which accorded with his modern sensibility.

What makes Degas "modern"? His subjects, such as bathers portrayed frankly, working women and shop scenes, are new or are handled in new ways. His technique is mixed, using a variety of materials and methods in unconventional ways. His formats of the fan and the elongated frieze are atypical of academic art. The uncentred compositions and off-balance subjects are fresh, as is the use of fragmentation, extreme vantage points and assertive close-ups. Stage lights render the human face distorted or curious. The mixture of artifice and illusion in stage scenery delighted the artist because he could play with painted theatrical "flats" in his own painting. The endless variety of devices allowed Degas to direct his own dramas, working from memory and invention in the privacy of his studio. Degas commented on his approach, saying, "I assure you that no art was ever less spontaneous than mine. What I do is the result of reflection and study of the great masters; of inspiration, spontaneity, temperament... I know nothing."

Degas began his career by drawing in pencil and chalk, painting in oils and etching. These were the dominant media at the time. Around 1869, Degas took up working in pastel; by the mid-1870s, it was his primary medium. For a long time disparaged as the medium of the amateur, pastels had been a favoured medium for portraitists in the preceding century, with pastelists Rosalba Carriera (1675–1757) and Maurice Quentin de La Tour (1704–1788) achieving fame. The medium declined in popularity but the introduction of new chemical pigments and renewed appreciation for de La Tour prompted French artists of the 1860s to try pastel. Pastel allows artists to work fast, unimpeded by drying periods. The colours are stronger and less diluted than those of paint. Degas had an unorthodox approach and used many supports, added liquid paint and experimented with fixative recipes to hold the pastel dust in place. There were stories of Degas placing his drawing on the floor, putting a board over it and stamping on it in order to grind the pigment into the paper. Like tales of Degas sunning his pastels on window sills to prefade them before use, there may be a degree of exaggeration in these reports. Degas went on to become widely considered the greatest pastelist of the century, demonstrating huge versatility and commitment to the medium.

In 1876 Degas took up making monotypes. Monotypes are made by drawing in ink on a metal plate and pressing a sheet of paper on it using an etching press, thereby transferring the ink design. Only one or two prints can be made by this method. Degas usually kept the first, dark print untouched and would go over the second,

Dancer Bowing with a Bouquet, c. 1877

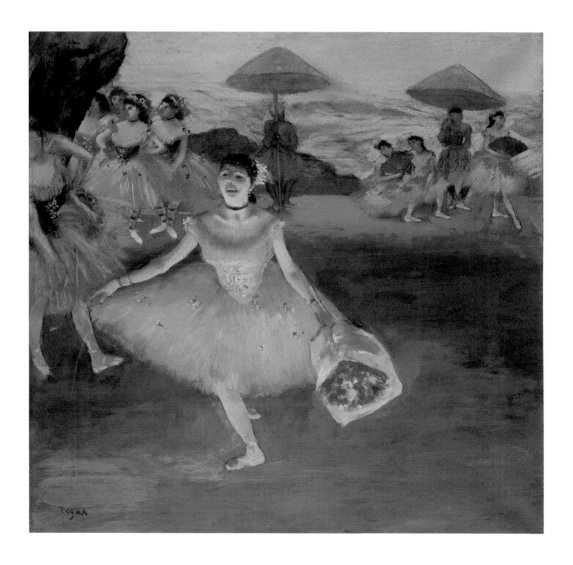

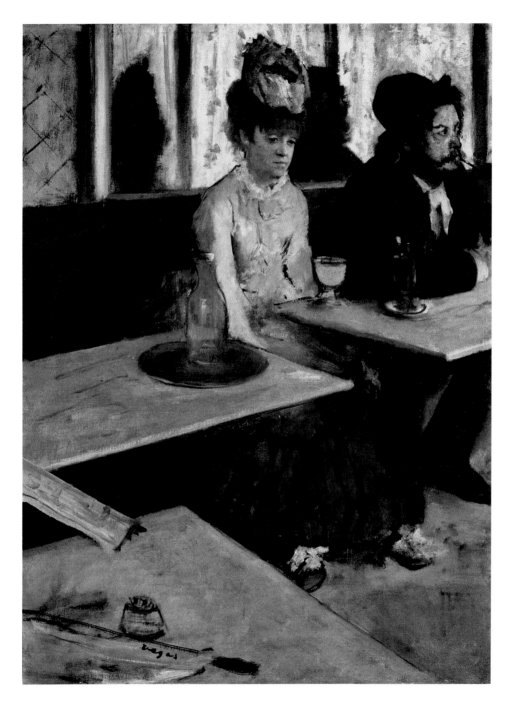

lighter print with pastel and gouache, often extensively altering it in the process. Degas's initial impetus was to illustrate stories about the family Cardinale, written by his author friend Ludovic Halévy and first published in 1872. This suite was mainly of brothel scenes. The prints range from the overtly comedic and caricatural—making fun of madames, prostitutes and clients—to scenes that are indistinguishable from Degas's bather pastels. These brothel scenes were virtually unknown to the public in Degas's lifetime. Other monotype subjects were ballet dancers and female bathers, alone or with their maids. The fact that the brothel scenes shade into pictures of bathers raises an interesting point. Who are Degas's bathers? Are they regular women in their homes or are they—as critics sometimes contended in the 1880s—prostitutes in brothels? There is not a clear answer. Degas took care not to provide narrative, context or titles to provide definitive information about the bathers. Knowing Degas's somewhat sardonic attitude, he was likely amused that the viewers' responses to the bathers betrayed their own expectations rather than the artist's intentions. Similarly, today we try to compartmentalise an artist's serious art and humorous caricatures, but with Degas's output ranging so fluidly between high and low subjects—not to mention the tone—it is not possible in his case.

Two examples of moral interpretation prove how potent Degas's ambiguity could be. *In a Café* or *Absinthe* (1875/6) shows a couple in a café or bar. The glass of milky absinthe suggests

the dissolute individuals are bohemians. Absinthe was a powerful drink, with some blends including impurities that acted as hallucinogens and poisons. It was a drink associated with artists and alcoholics. When he first saw this painting, Irish writer George Moore, who knew Degas, announced that the picture was degraded and immoral. He damned the woman as a prostitute. Actually, the model was actress Ellen Andrée, who had also sat for Manet. Moore later regretted his comments and admitted he had over-reacted. Another flashpoint of moral outrage was caused by Degas's only exhibited sculpture. Before we get to that, however, we should gain an overview of the independent exhibitions and the Impressionists.

In an attempt to reach a wide audience—and to circumvent the capricious and censorious Salon jury—Degas co-founded the Société Anonyme Coopérative des Artistes Peintres, Sculpteurs, Graveurs (Co-operative and Anonymous Association of Painters, Sculptors and Engravers) in 1873. The following year, the first independent exhibition of new art was held at Nadar's photographic studio. Apart from Degas, exhibitors included Claude Monet, Berthe Morisot, Camille Pissarro and Pierre-Auguste Renoir. The exhibitors came to be called "Impressionists", after a title used by Monet for one of his paintings. Degas himself preferred to be called a realist. During the the next twelve years there were eight more independent exhibitions, including art by Mary Cassatt, Alfred Sisley, Paul Gauguin, Georges Seurat, Paul Signac, as well as that of

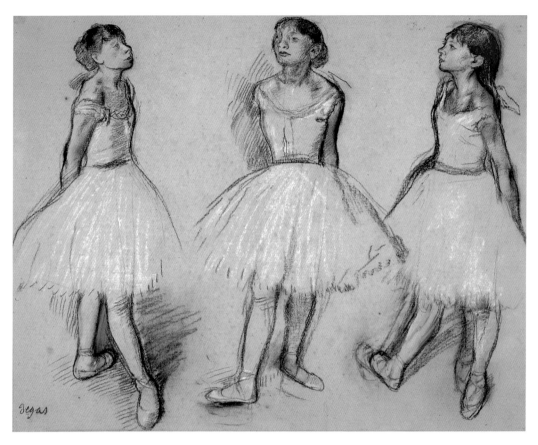

Three Studies of a Dancer in Fourth Position, 1879/80

other exhibitors. Manet was invited to participate but his pictures were accepted by the Salon, so he declined the offer.

In 1881 *Little Dancer Aged Fourteen* (page 75) drew heavy criticism. Not only was the novel technique criticised, there was strong moral disapproval. Just as Manet's *Olympia* had caused a furore in 1865, so Degas's statuette raised moral issues. From the plentiful comment, it appears viewers were disturbed by a realistic depiction of a ballerina they would normally see as an elegant image on stage through opera glasses. She was so obviously lower class that many bourgeois gallery-goers felt a visceral reaction: their space was being encroached upon by a member of the "dirty and ugly" lower order. Hard as it is to comprehend such hostility today, we should recognise that generally thoughtful and compassionate individuals would actually avert their gaze when encountering Degas's dancer.

This aversion to dancers was not sheer prejudice. Many dancers led notoriously louche

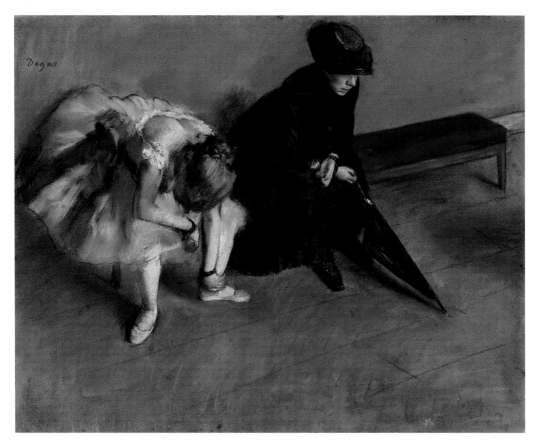

Waiting, c. 1882

lifestyles that were encouraged and funded by gentlemen. They were constant topics of gossip columns, often having outrageous affairs and losing positions due to their behaviour. Achille De Gas had an affair with an ex-dancer; the affair ended when Achille tried and failed to shoot her husband in the street. The girl who modelled for *Little Dancer Aged Fourteen* had two sisters who were also dancers: one became a respected ballerina and teacher, the other became a thief. For every star ballerina, there were a handful of ex-dancers soliciting drinks in unsavoury bars of Montmartre.

The casual perception is that Degas's ballet pictures are insubstantial or uncritical. That is incorrect. Degas showed the stress and effort of ballet, also the boredom. *Waiting* conveys the tedium of training and watching for hours while dancers acquire skills and learn routines, all in conditions that were far from glamorous. If we study the ballet pictures we get a sense of Degas's keen empathy with the struggle of

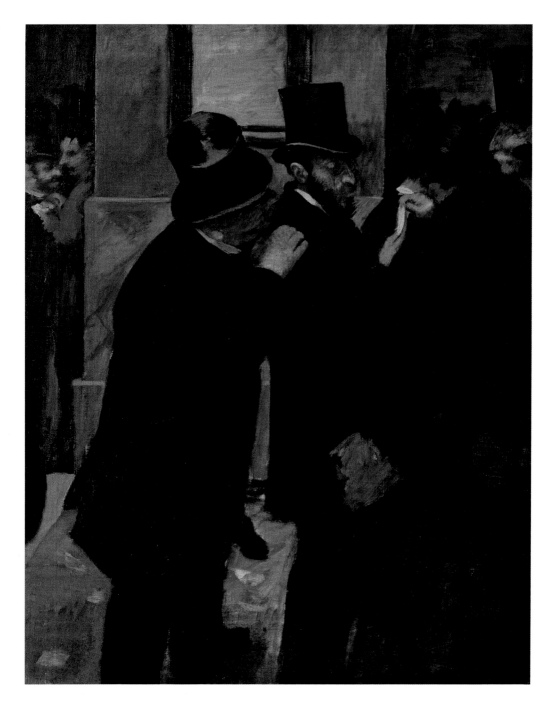

individuals to make something of great accomplishment through hard work. It may be that Degas felt a kinship with dancers and—in his pictures—was making an analogy between dance and art, with both requiring artifice, stamina and time to perfect.

Degas's social circle of artists was very broad, in addition to the Impressionists and other artists already mentioned, Degas was also on familiar terms with Jacques-Émile Blanche, Giovanni Boldini, Léon Bonnat, Jean-Louis Forain, Henri Gervex and James Tissot. These cannot be classified as Impressionist, academic or strictly Social Realist (see page 80 for a discussion of Social Realism). These artists have been called Cosmopolitan Realists. They portrayed the middle-class and city life with painterly panache, flattering their subjects. Degas was an avid art collector, buying and exchanging in order to attain art by his colleagues and art of the greats, including Ingres.

The independent exhibitions formed a bond between Degas and Mary Cassatt (1844–1926). In the late 1870s Degas worked closely with Cassatt, an artist from Philadelphia who moved to Paris to advance her career. Cassatt was known for painting scenes of women and mothers with young children. She worked in oil and pastel and made some exceptional prints in colour. Her painting and pastel technique recall Degas's but her colour prints are very dissimilar to his. Cassatt invited Degas to correct a picture of hers and he painted some background of her *Little Girl in a Blue Armchair* (1878). Degas drew and painted Cassatt, gave advice, helped her sell art and bought her pictures. Between 1879 and 1880 Degas was organiser of a project to publish an illustrated journal of prints, aimed at conoisseur book collectors. *Le Jour et la Nuit* (Day and Night) was to feature Impressionist prints by Degas, Cassatt, Pissarro and Félix Bracquemond. Each developed prints ready for publication but the journal never appeared. Increased competition and financial uncertainty presented hurdles that appeared too formidable and Degas cancelled the venture.

Perhaps inspired by time spent with the well-dressed Cassatt, in 1879 Degas started a series of pictures of milliners and female customers. Cassatt was the subject of some drawings of women wearing hats, all with her face obscured. The shop scenes allowed Degas to mix social commentary and insight into human behaviour, while at the same time delighting in the rich colours and variety of textures of the hats. Degas seemed fascinated by what we could call female spaces: the boudoir, brothel, laundry, department store and dance studio. *Portraits at the Stock Exchange* (page 28) is a glimpse into a male space, the Paris stock exchange.

Degas's restless engagement with materials led him to paint fans, sometimes with touches of metallic paint. For *Beach Scene, Little Girl Combed by her Maid* (pages 32/33) Degas used essence, which is oil paint with most of its oil removed and replaced with a mineral or turpentine thinner, making it more suited to painting on paper. He used tracing paper and transparent

celluloid, he traced, he made counterproofs by running a pastel through an etching press with another sheet of paper, thereby producing a fainter, inverted version of the original. He used photomechanical reproduction, lithography and etching. His photography and sculpture are discussed below. No other nineteenth-century artist was more experimental than Degas.

After the final independent exhibition in 1886, Degas exhibited less often, mainly selling directly to dealers. After 1886 there is a change in his output. He turned away from Realism and dwelt on the figure detached from context. No new subjects appeared in his art, as he concentrated on finding greater richness in the subjects of bather, dancer and horse. The painter's empathy for people of all stations, ranging from the haute bougeoisie to laundresses, is mirrored by his sympathy for animals. The sequential action photography of Anglo-American photographer Eadweard Muybridge (1830–1904) revealed much about the locomotion of human beings and domesticated animals, including horses. For the first time, high-speed photographs recorded how animals and people moved. Muybridge's series were a goldmine for artists; Degas would have encountered his horse photographs in December 1878, when *La Nature* published them in France. Muybridge's *Animal Locomotion* was not published in full until 1887. Degas used Muybridge's photographs of horses as references for his sculpture.

After Degas's death, his heirs found crumbling statuettes of horses and female nudes, modelled in clay, wax and Pastilene, lying dusty in his studio. It had long been known that Degas made sculpture in private but only the *Little Dancer* was ever exhibited. As early as the 1860s, Degas was modelling small figures and horses. He made plans to cast some in plaster but only proceeded a couple of times. Preserving pieces in bronze did not appeal to him. He allowed the figurines to fall apart, mending them haphazardly or leaving them broken. By 1917, his heirs discovered all the pieces were in bad condition. An expert went through the material and restored seventy-four sculptures to be cast in editions in bronze and offered for sale. The original *Little Dancer* was found and bronzes were cast from it also.

As we would expect, Degas's sculpture expands the limits of the medium. *The Tub* (page 35) includes the tub and water in which a bather lies. Tableaux including figures, furniture and objects can be found in funerary monuments of the period (and earlier) but the concept of a domestic scene—something so mundane and everyday—being worthy of immortalisation in sculpture is unusual. It is assumed that sculpture became more important to Degas as his sight failed. This idea downplays the amount of sculpture Degas was making in the 1870s. Many of the earliest pieces were so degraded (or even disposed of) that, by 1917, what remained was mainly late in date, distorting an accurate understanding of his sculptural oeuvre.

In the 1890s Degas took up photography. He photographed his friends and himself. In a self-deprecating photograph, Degas posed as

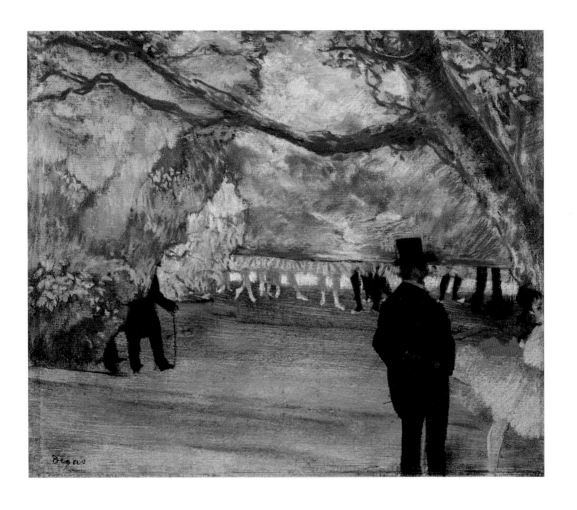

The Curtain, c. 1881

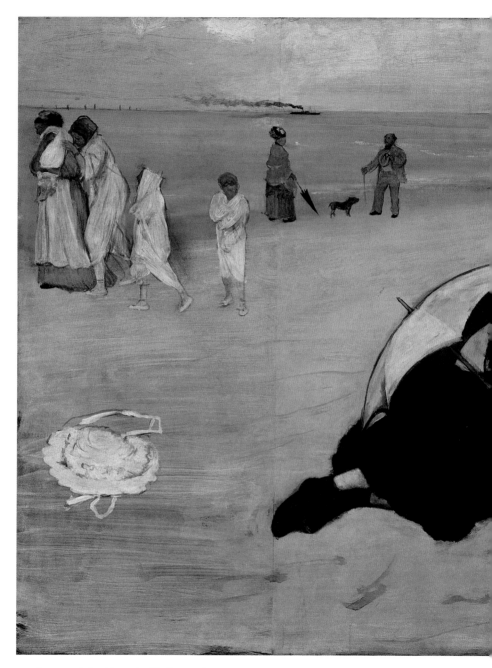

Beach Scene, Little Girl Combed by her Maid, c. 1877

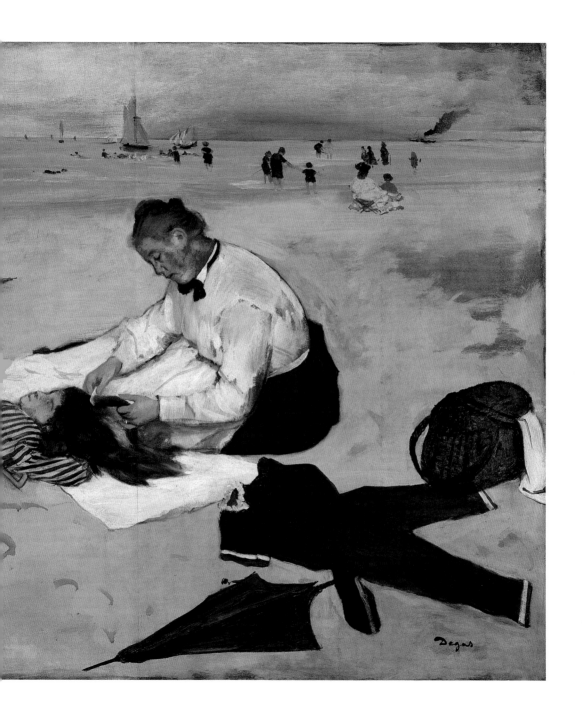

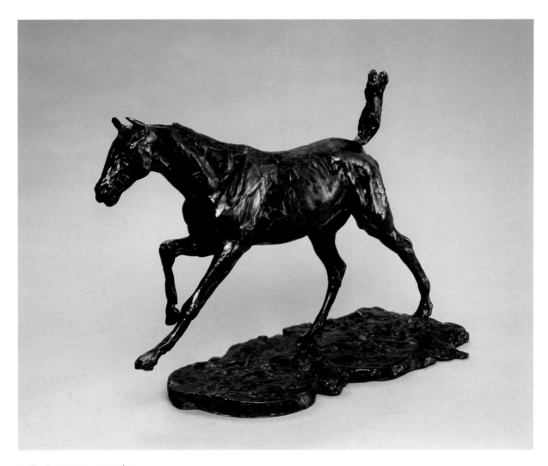

Galloping Horse, c. 1889/90

glum Homer receiving the accolades of posterity. He also took photographs of nudes and dancers. Some of these were sources from which he painted. Although he must have taken many more, only about forty of Degas's photographs survive today.

During the late 1890s and early 1900s, the Dreyfus Affair split French society. Alfred Dreyfus, a Jewish army captain, was convicted of treason and was later exonerated. Many people took one of two sides: Dreyfusard and anti-Dreyfusard. The former tended to be more socially liberal and politically left; the latter were more strongly Catholic and patriotic, many expressing anti-Semitic opinions. Degas was an anti-Dreyfusard, which divided him from some friends and colleagues. Some of those relationships never healed. It is hard to pin down Degas's politics. Despite his caustic comments, all we can say for certain is that Degas expressed increasing

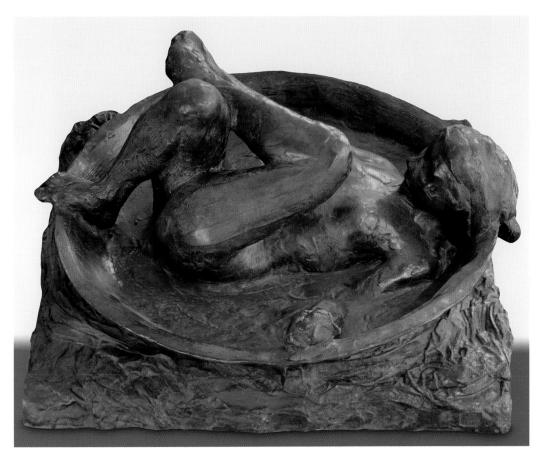

The Tub, c. 1889

suspicion and pessimism. After all, Degas was a supportive and good friend to Pissarro (a Jew and anarchist), Halévy (an ethnic Jew), Cassatt (a woman artist) and Tissot (a Communard).

In September 1889, Degas and Boldini visited Madrid, where they visited the Prado and a bullfight, before travelling to Tangiers, Gibraltar and Granada. Reports were that Degas's eyesight was becoming severely impaired. By 1895, colour had become vivid, even painfully intense. In the pictures of the 1900s, shapes start to detach from their sources, floating free on the picture surfaces. Outlines of figures on tracing paper became thicker and less exact, as Degas struggled to see what he was making. Model Alice Michel wrote that Degas once asked her to tell him the colour of the pastel he was holding, demonstrating how damaged his eyesight was.

By 1900 the artist was largely reclusive and increasingly isolated. It is thought that Degas

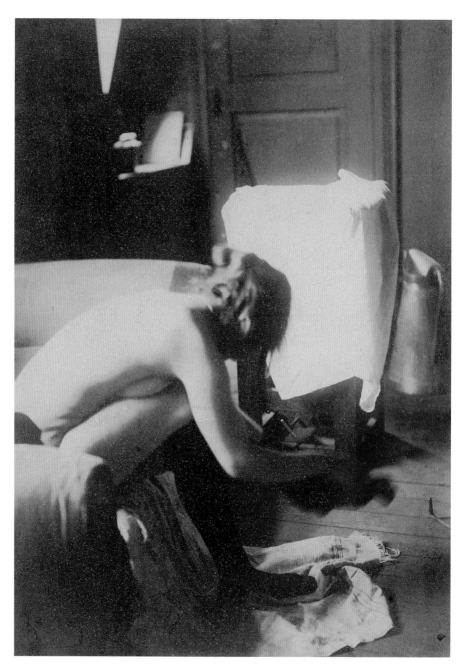

Nude Photographic Study, 1895

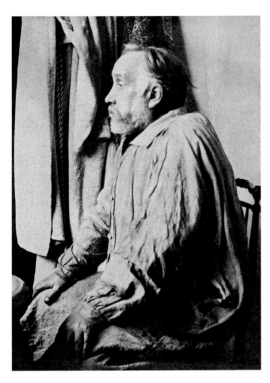

Attributed to Bartholomé, Photograph of Degas in his Studio Rue Victor Massé, c. 1898

stopped making art around 1910. In 1912 friends (including model-artist Suzanne Valadon) assisted in finding Degas a new apartment on Boulevard de Clichy, IXᵉ arrondisement following enforced departure from his apartment on Rue Victor Massé. There is no record of him making art at his last residence. Edgar Degas died on 27 September 1917. Cassatt wrote, "Degas died at midnight not knowing his state. His death is a great deliverance but I am sad... He was my oldest friend here, and the last great artist of the nineteenth century—I see no one here to replace him."

Although there may be art that is grander, more beautiful and more intellectually sophisticated than Degas's, there may be no art that tells us more about what it is like to be human—to exist in our bodies, to be with other people and to feel a variety of emotions at the same time, whatever our era or culture. That is why Degas's art continues to exert such a powerful hold over us, even today.

WORKS

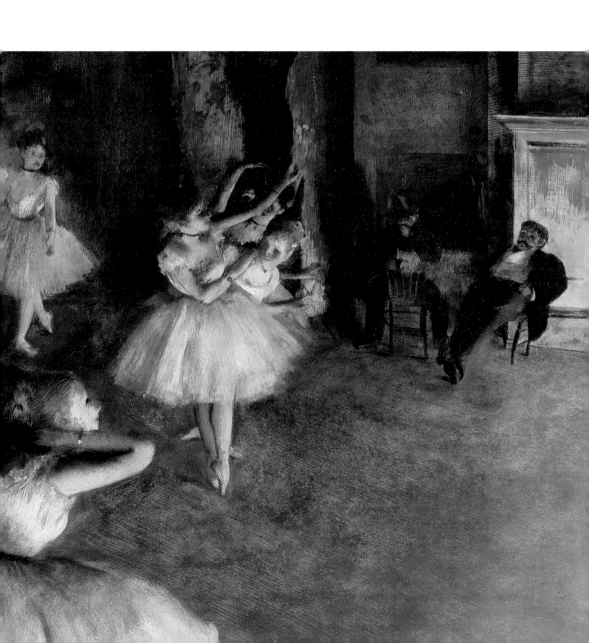

The Bellelli Family, 1858–67

Oil on canvas
200 × 250 cm
Musée d'Orsay, Paris

Painted in Paris after an extended stay with the Bellelli family in Florence (from July 1858 until March/April 1859), Degas's first major group portrait is surprisingly complex for a young artist. It is unconventional in composition and tone. Typically, Baron Gennaro Bellelli, as head of the household, would have been placed at the centre, with wife and children occupying less prominent positions. In this case, the reverse is true. Laura Bellelli née Degas (Degas's paternal aunt) is dominant. She resented the fact that her family was exiled from their native Naples due to her husband's politics. When this portrait was begun, she was pregnant. The standing daughter is Giovanna, the seated one Giulia. The drawing on the wall is a portrait of Hilaire Degas, Laura's recently deceased father, who had thwarted her wish to marry a different man.

The unhappiness of the marriage is embodied in the postures of the individuals. The husband has turned away from his family and his wife; both husband and wife seem emotionally distant, even melancholic. This rear-facing seated man looking sideways towards a woman echoes Titian's paintings *Venus with Musician*, well known through reproduction prints. Giulia has one leg folded under her, displaying an informality that was unexpected in portraits of the era. Including such informality, unconventional composition and recording emotional estrangement in a grand family portrait was, in its way, every bit as radical as Degas's treatment of the nude figure in his later years.

The picture—intended as a demonstration of modern portraiture rather than made to private commission—was painted over a long period and finally exhibited at the Salon in 1867 entitled "Family Portrait", without revealing the artist's connection to the subject. It stayed with the artist and was purchased by the French state in 1918, when Degas's studio contents were auctioned following his death. Degas executed a full composition sketch in pastel, dated about 1858–62—a rarity in Degas's practice and evidence of careful preparation of this landmark work.

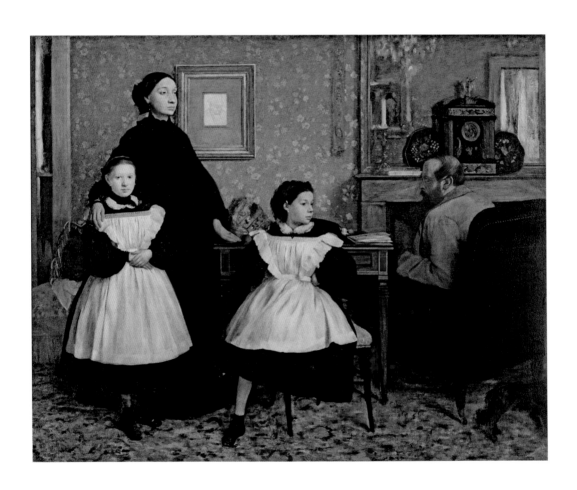

Sulking, c. 1869–71

Oil on canvas
32.5 × 46.5 cm
Metropolitan Museum of Art, New York

The models for this picture were Degas's friends Emma Dobigny and Edmond Louis Duranty, critic and novelist. Another title for this painting is *The Banker* and the setting for the scene was probably the bank office of Degas's father, at Rue de la Victoire. On the wall is a colour reproduction print of *Steeple Chase Cracks* (1847), a classic sporting picture by the English painter John Frederick Herring Sr. (1795–1865), reflecting Degas's enthusiasm for sporting art, especially English equestrian art. The picture has influenced interpretation of this tableau, with some writers suggesting this is a married couple (or father and daughter) arguing over the man losing money gambling on horses or that the man is a bookmaker. Whatever has occurred in this encounter, the man is angry or ashamed, unwilling to respond to the attentive woman.

Degas was an adroit observer of behaviour and body language. He mastered the conversation piece, an informal group portrait in a domestic setting. Although he soon turned away from Realism and genre painting—and thus painted relatively few conversation pieces such as this painting—Degas's competence in this field informed his ability as a portraitist. *Sulking* is the pictorial equivalent of the realist novels by Émile Zola that so many (including Degas) admired.

Dobigny, who also modelled for Corot and Tissot, was actually Marie Emma Thuilleux (1851–1925). She was the subject of a small, exquisitely delicate portrait by Degas, painted about this time and currently in a private collection. In 2016, scientists deploying imaging technology discovered a portrait of Dobigny under an unrelated Degas painting. I propose that Dobigny is the female model for *The Interior* (1868/9) in Philadelphia.

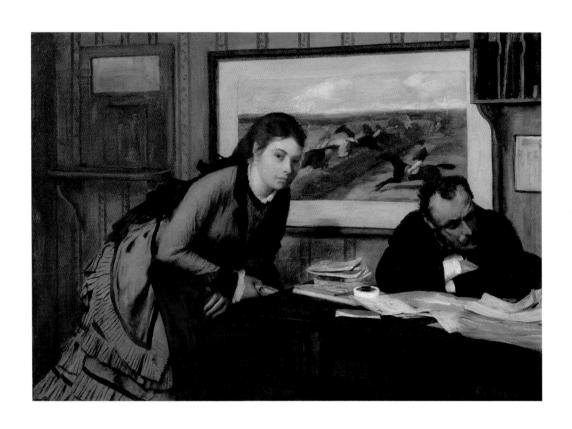

Seated Dancer, c. 1873

Pencil, charcoal and chalk on pink paper
42 × 32 cm
Metropolitan Museum of Art, New York

This drawing, with its combination of careful observation and artistic panache, demonstrates skills acquired from drawing *academies*—life drawings made using pencil and chalk, often on tinted paper. All students were expected to master this skill before being permitted to begin studying oil painting. Although Degas himself did not complete formal education in the École des Beaux-Arts, it was not due to any rebelliousness or rejection of the importance of academic principles. Degas effectively trained himself by rigorously copying old art and drawing from life, particularly at the Villa Medici in Rome (see *Nude Study*, page 12).

Degas adulated the Neoclassical painter Ingres. Ingres made delicately modelled, realistic figure drawings, such as this one. When they met, Ingres advised the young artist "always make lines, lots of lines". Ingres was famed for his society portraits and admired by other artists for his skill as a draughtsman, yet he was eager to achieve respect as a great History painter, comparable to Nicolas Poussin. Yet Ingres's grand paintings of mythology and history met with mixed public receptions. He never adjusted to the taste of his time. When, soon after his Salon debut in 1865, Degas abandoned his desire to be a History painter, he showed that he had learned from his hero's error. Degas decided to depict not medieval heroines but working-class girls caught in the endless toil and fleeting glamour of the dance stage.

This drawing was intended as a preparatory study, not for public display. Other drawings in this group—all made on pink paper—have faded considerably due to exposure to sunlight.

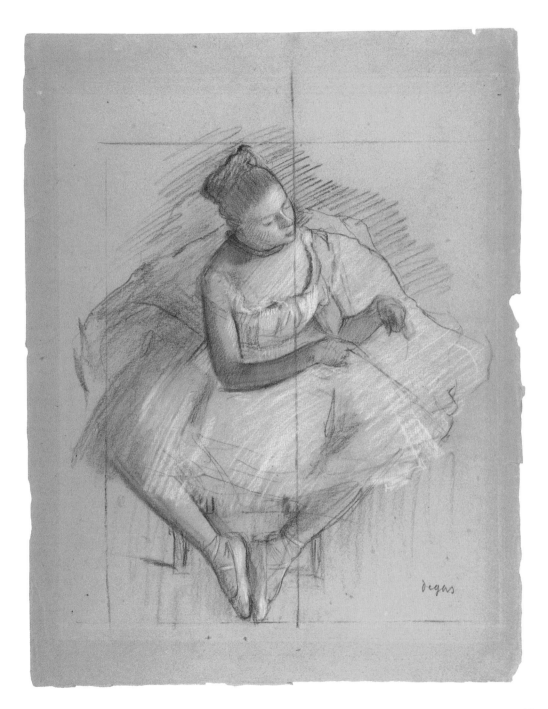

The Ballet Class, 1873–1875/6

Oil on canvas
85 × 75 cm
Musée d'Orsay, Paris

Here we see a class of young dancers being drilled by a master. Some appear attentive, others are bored or tired. In the foreground a watering can and a small dog can be seen.

The dance master has been identified as Jules Perrot. He was a former star dancer, who became a choreographer and ballet teacher at the Opéra after his retirement from the stage. At the time Degas started this picture, Perrot was sixty-three years old. He appears in a number of other ballet scenes and pencil sketches made by the artist in situ. There are two versions of this painting, both were started around the same time. Degas returned to this version a few years after he initially completed and revised it. The alternate version has a large mirror instead of a doorway. The artist seems to have exaggerated the height of the room. Such a distortion makes the setting more imposing and renders the dancers smaller and hence younger than they were in real life.

From around the late 1860s to the mid-1880s, Degas was concerned to make art that reflected real life. Degas's realism was always selective and heightened. The dancers here are compressed into a small area of the practice studio—they are in danger of injuring one another if they actually attempt movement. The perspective is exaggerated to emphasise the grandeur of the setting, which counterpoints the prosaic experience of routine exercises. Pure naturalism is often disappointing or unsatisfactory. What Degas did was condense and organise what he saw to make it more memorable and allow him more freedom in composition. Later, realism would drop away in favour of intensity of sensation; *The Ballet Class* is a good example of Degas's early-period heightened realism.

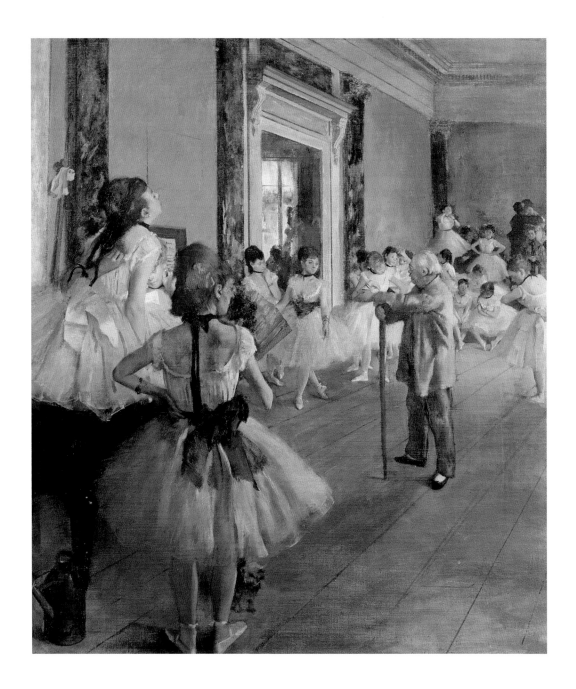

The Rehearsal of the Ballet Onstage, 1873/4

Oil paint, essence and watercolour over brush-and-ink on paper
53.3 × 72.3 cm
Metropolitan Museum of Art, New York

Here we see master Perrot again, this time directing dancers at the last stage of pre-performance rehearsals. The dancers are on stage in full costume and illuminated by stage lights. The two gentlemen seated at the side of the stage seem incongruous and inexplicable to us but in the nineteenth century many viewers would have understood their presence. At the Paris Opéra, it was common for patrons, who donated to support the institution, to have access to rehearsals and backstage areas. It was not uncommon for patrons to not only enjoy the company of dancers backstage but also receive sexual favours from them. Another version exists with the gentleman on the right removed.

The peculiarly complicated technique of this picture requires explanation. Degas made an ink drawing for the *Illustrated London News* in 1873. Perhaps intuiting the undertones of sexual impropriety, the editors rejected the drawing as indecent and returned it to the artist. Degas later elaborated the drawing by applying watercolour selectively, then oil paint and essence. It is an unorthodox technique that no artist would have planned in advance, due to the incompatibility of materials and the difficulty of correction.

This painting was acquired by philanthropist Louisine Havemeyer on the advice of Mary Cassatt. Other paintings Cassatt recommended included *Sulking* (page 43), *Woman Ironing* (page 51), *Dancers practicing at the Barre* (page 57) and *Female Nude Having her Hair Combed* (page 95). These paintings were donated to the New York Metropolitan Museum in 1929, consequently giving New York one of the best collections of Degas's art in the world.

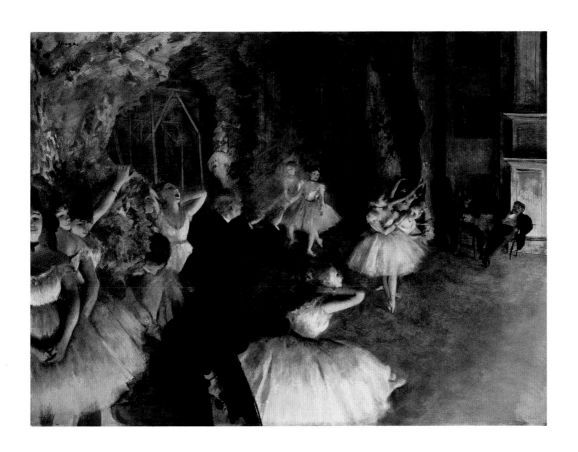

49

A Woman Ironing, 1873 or 1874

Oil on canvas
54.5 × 39.5 cm
Metropolitan Museum of Art, New York

On 13 February 1874, Edmond de Goncourt wrote, "Yesterday I spent the afternoon in the studio of a painter named Degas. [...] Degas placed before our eyes [pictures of] laundresses [...] while speaking their language and explaining to us technically the downward pressing and circular strokes of the iron."
The development of photography presented painters with new problems and insights. One challenge was that photography seemed to make the documentary function of painting redundant. It forced artists to record the world in ways photography could not. One of the main drives of Impressionism was to revitalise painting by tapping its expressive capacity (often through its sheer materiality) and reducing the role of painting as mere tedious description. Nineteenth-century painters realised that they could use the characteristics of photography to create a new kind of painting that was true to life yet unlike the art that had come before. Photography has a limited tonal range; a single photograph cannot display all the wide tones from black to white while also recording greys accurately. There is a bias that the photographer must control through the aperture and exposure length. In this painting, Degas exploits a typical photographic effect, the contre jour. This occurs when a solid body in a dark space is lit strongly from behind. One tends to see a dazzlingly bright background and a shadowy object, almost as a flat silhou- ette. In conventional academic paintings, the background would be detailed and the figure rounded, painted in a wide variety of tones and colours. Degas here uses his understanding of photography to create a painting with photographic verité, something radically reduced in colour and tone, made memorable by his vigorous technique.

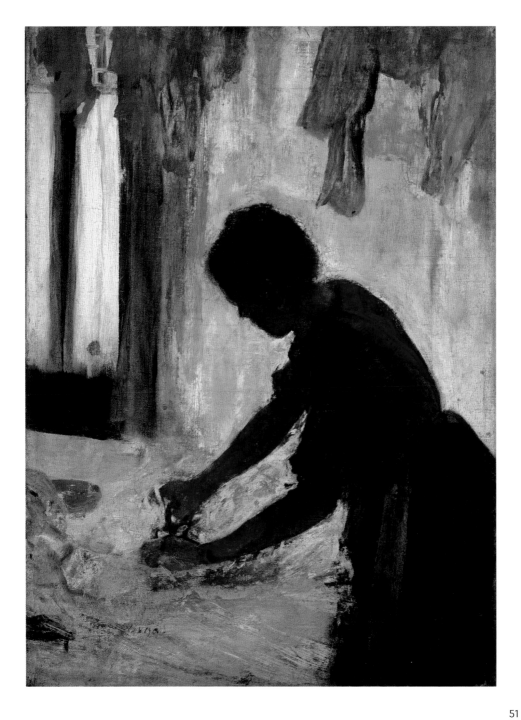

51

At the Café, c. 1875–77

Oil on canvas
65.7 × 54.6 cm
Fitzwilliam Museum, Cambridge

The question of finish was one that preoccupied artists, critics and art collectors in the Impressionist era. It was perhaps the main cause of the hostility towards Impressionist painting. This picture—almost a companion piece to *In a Café* or *Absinthe* (page 24)—appears unfinished because the primer undercoat is visible. Yet it may be that Degas had completed the figures to his satisfaction and found that the brusquely brushed background and chairs were sufficiently delineated to need no further elaboration. The painting is functionally complete. This picture—which, if it had been completed in the conventional manner, might have been rather dark and static—benefits from the lively brushwork and Degas's *sprezzatura*, which is a way of executing something with a flourish that conceals hard work under apparent nonchalance. A pervasive impression of reality frozen—evident in the relaxed poses of the women—anticipates reportage photography. Even the muted colour, almost monochrome, and the blurring are photographic in quality. According to standards of the time, exhibiting an unfinished picture offended not only taste, it raised the question of integrity. Was the artist offering shoddy goods by attempting to pass off an *ébauche* (a loosely painted sketch) as a finished work of art? The issue was so controversial that when, in 1877, critic John Ruskin publicly condemned a painting of fireworks by James McNeill Whistler—by writing that the painter was "flinging a pot of paint in the public's face"—it led to a lawsuit. The claim was that the artist was both insulting and cheating the public by exhibiting a painting that was not fit for public display and sale. The charge that the Impressionists were charlatans swindling the public caused artists to defend their honour and critics to uphold their values. Due to his experimental technique and choice of under-class subjects, Degas was, among all the Impressionists, subject to the most aggressive criticism.

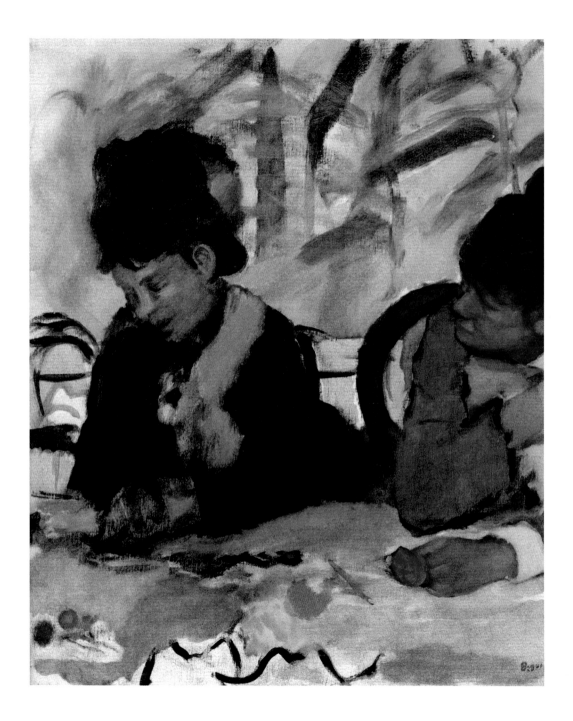

The Star, 1876/7

Pastel over monotype on paper
58 × 42 cm
Musée d'Orsay, Paris

In this picture, the prima ballerina takes centre stage in the newly opened Palais
Garnier, the home of the Paris Opéra, to dazzle the audience. Her white tutu skirt
shimmers under the lights as she performs an *arabesque* or *attitude*. Degas, never
one for a cliché, shows us other dancers in the wings and a man in a suit providing
a dark counterpoint to her burst of brilliance. The Cardinale stories that these
images relate to, includes a gentleman-patron watching his protégé from the wings.
In this scene of a star at the apex of her performance, Degas undercuts the glamour
by reminding us that their are others waiting for their cue. Scrutiny of Degas's
pictures depicting dancers on stage reveals that there are almost no pictures
that could be called unambiguously pretty or straightforward. Degas instinctively
searches for the strangeness in tableaux that could have been made purely celebra-
tory. The subject has been identified as Spanish star Rosita Mauri (1850–1923), who
was portrayed by many artists, including Renoir and Anders Zorn.
This pastel was acquired in 1877 by Gustave Caillebotte, painter and collector. In
his will, enacted upon his death in 1894, he donated his collection to the French
state. *The Star* was one of seven pictures by Degas included in the donation. As it
happened, the French state at that time was not at all enthusiastic about housing
a group of Impressionist pictures. Degas and Renoir were involved in protracted
negotiations between the heirs and the state. In the end, the state accepted only
half the Caillebotte bequest, deeming the remaining pictures unsuitable.
Another monotype of this composition exists in the Art Insitute of Chicago, and is
made very differently. It includes part of another dancer at the bottom right and
the *corps de ballet* in a line behind the main dancer.

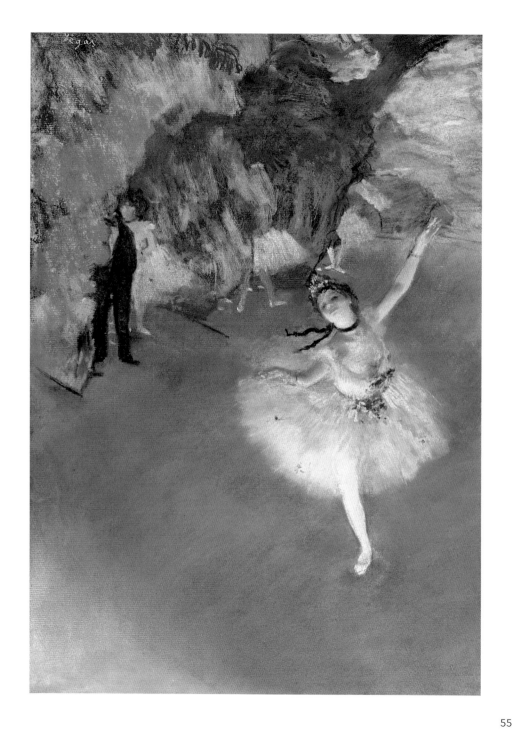

Dancers Practicing at the Barre, 1876/7

Mixed technique on canvas
75.6 × 81.3 cm
Metropolitan Museum of Art, New York

Here ballet dancers practise at the barre. A watering can has been used to lightly sprinkle the floor to lay the dust. The sprinkled water and the echoes of the legs create a satisfying pattern. The prominent diagonals in Degas's compositions may have been derived from Japanese prints, which were very popular in Paris from the 1860s onwards. The craze for *japonisme* influenced fine art. Vincent van Gogh collected Japanese colour woodcuts and even made painted copies of them. Theo, Vincent's brother, was a Paris art dealer who bought and sold Degas's art.
Degas used patterns to animate picture space. Wallpaper designs, folds of cloth, blades of grass and other material—even repeated figures wearing similar clothes—create patterns in Degas's pictures. They are pleasing to the eye and produce visual pulsation, imbuing energy. Due to an inherited biological imperative, the human eye seeks patterns, allowing individuals to understand the world around them. Spotting an anomaly in a pattern can warn an individual about the presence of a predator and thus save his or her life. Our thirst to seek and create patterns—which we find satisfying—is something that artists have instinctively understood even without knowing the origins of the tendency.
Degas had second thoughts about this painting. He asked the owner if he could paint over the watering can, finding the visual pun of it echoing the pose of the girl on the right too obvious. The owner, knowing of Degas's propensity to rework whole pictures, declined his suggestion.

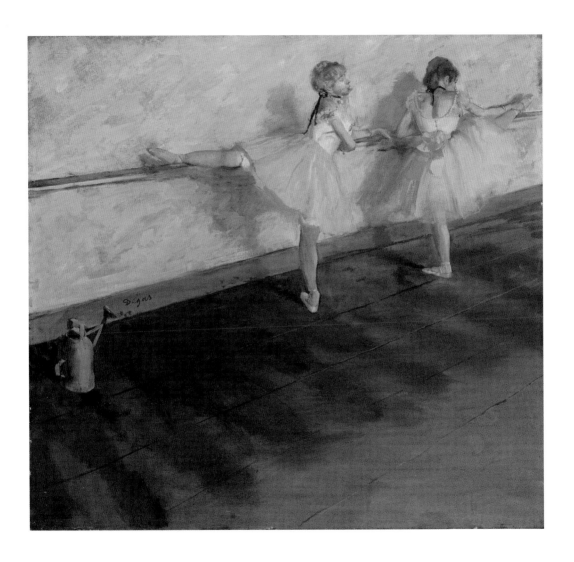

The Race Track: Amateur Jockeys Near a Carriage, 1876–87

Oil on canvas
66 × 81 cm
Musée d'Orsay, Paris

Degas visited England at least three times that we know of. Two of these were business trips to London; another was to Liverpool to catch a steamship to America. No art made by Degas on these occasions has been identified. Historical antagonism, warfare and the generally low standard of English art, meant that when artistic influence flowed between France and England, it emanated from France. Eugène Géricault was the first modern French artist to pay attention to England. Géricault was a fanatical horseman, who became obsessed with the British sport of horse racing. In England, he drew horses of all types and in all situations, turning these vignettes into a suite of lithographic prints. After the Napoleonic wars, the French upper class began to cultivate anglophile tastes in terms of customs, clothes and sport. Géricault, and later Delacroix, opened French artists' eyes to British art, specifically to landscape painting and equestrian art.

Degas's engagement with equestrian subjects was present at least as early as 1860, but horses were a staple subject in every artist's training, so he is likely to have drawn them from the mid-1850s onwards. Degas had left behind History painting as a genre, but being a painter of modern life entailed painting horses, the primary method of transport of the era. Horses and nudes were two subjects which a modern painter could pursue while maintaining a connection to the art of the Old Masters. In this scene, the snapshot quality of ordinary life frustrates the expectations of viewers familiar with traditional composition. There seems to be no central motif; figures are partially hidden; the centre of the foreground is empty. A figure on the right is reduced to merely an arm, a patch of face and half a hat. That figure, a carriage and three jockeys and horses are compressed into a single block. What appears to be a confusing mass is a way of getting us to look hard to discern component elements, forcing us to concentrate. Aware of the effect of accidental cropping in documentary photography, Degas uses this supposedly arbitrary grouping of motifs to evoke reality while at the same time allowing himself to experiment with an off-centre composition that is fresh and energetic.

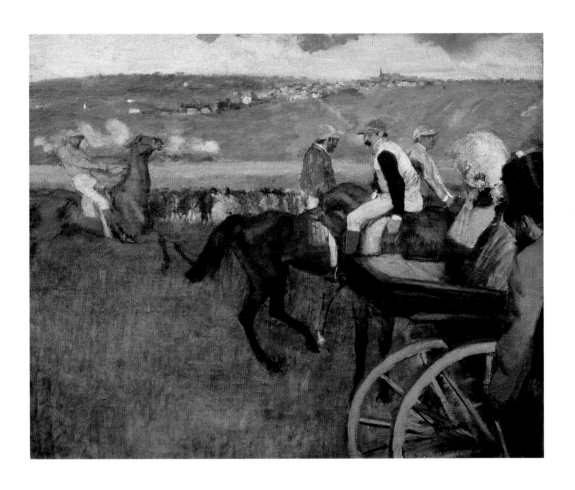

At the Café-Concert—The Song of the Dog, c. 1876/7

Gouache and pastel over monotype on joined paper
57.5 × 45.5 cm
Private collection, France

At a café-concert, famous chanteuse Thérésa (Eugénie Emma Valladon, 1837–1913) stands on a stage overlooking a park at night, illuminated from below by gas footlights. She imitates the dog by holding up her hands as paws. Yet Degas was not choosing a cabaret performer only due to the piquancy of her comic routine; he was genuinely enraptured by Thérésa's voice and stated in a letter that her singing was "better than that of the Conservatoire". Degas was no snob and never mouthed empty pieties.

The gilded pillar divides the dim exterior space the same way the singer's choker divides her throat. The strong, bright vertical provides strong contrast to the composition. Degas uses visible discrete sources of light in the picture—the round lamps—and strong lighting from below. A century later, director Stanley Kubrick used similar lighting approaches in his later films. The advent of electric light in 1877 noticeably changed Paris and informed the art of the Impressionists and Post-Impressionists. Written descriptions of performers under electric light appeared that year.

This picture was constructed using a complex technique that Degas improvised as he worked. The original design was a monotype in black ink on white paper. Degas then added colour with pastel and gouache paint; he may have added water to the pastel to dissolve it into a liquid. The artist affixed strips of paper to the edges to expand the picture. Degas later produced a simplified version of this composition as a lithograph, as well as authorising a master print maker to make a close replica of this painting. Degas made a series of related pictures of other café-cabarets featuring singers making theatrical gestures. Paintings such as this influenced Henri de Toulouse-Lautrec, who adulated Degas's art, to paint his own cabaret pictures.

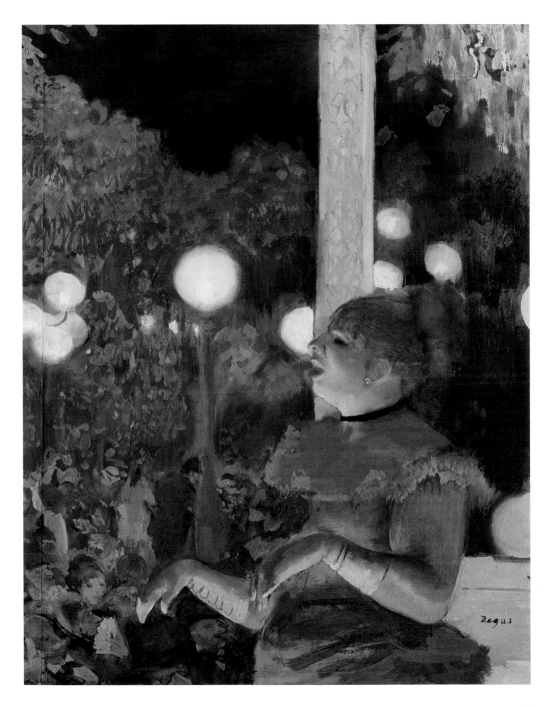

61

Swaying Dancer (Dancer in Green), 1877–79

Pastel and gouache on paper
66 × 36 cm
Museo Thyssen-Bornemisza, Madrid

In Degas's pictures of bathers, limbs are often concealed behind furniture or towels, leaving the head and torso as frequent constants. In the dancer pictures, such as this one, the reverse is true: the torso is hidden by the tutu, leaving the limbs visible. In this view, the dancers appear to float free of gravity, like dandelion seeds. The dancers in the foreground tumble down towards us diagonally, emphasised by the diagonal shading of the stage; the dancers in red-orange remain horizontally arrayed, stolidly earthbound and inactive. Thus the two groups of dancers provide a direct contrast to one another. Black gouache has been applied to the scenery at the top of the picture. Gouache, a water-based opaque paint, works well in combination with pastel, which is also soluble in water.

The blue-green of the foreground dancers and the red-orange of the ones in the background are absolute complementaries on the colour wheel, as Degas would have known. Complementary colours are especially satisfying because, when paired, they highlight and "complete" each other. Juxtaposing these hues heightens the impact of both. The details on the blue-green skirts on the fringes, in dark green and pink, adds a spattered orbit of contrasting hues.

In 1880, Joris-Karl Huysmans, a critic very familiar with Degas's art, wrote the following: "For a moment, under the streams of electric light inundating the stage, a whirlwind of white tulle appears, spattered with points of blue light, and, in the centre of it, a writhing circle of naked flesh; and then the *première danseuse* [...] dances on her toes for a while, shaking the false sequins which surround her like a circle of golden dots; then she leaps in the air, and sinks back into her skirts, imitating a fallen flower with its petals on the ground and its stalk in the air."

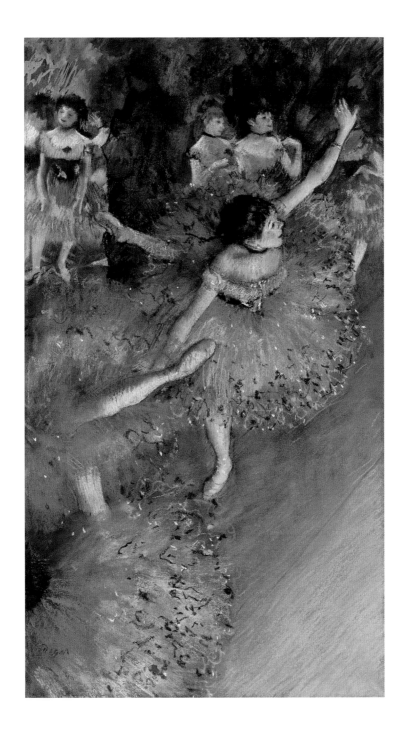

Dance Examination, c. 1879

Pastel and charcoal on grey paper
63.4 × 48.2 cm
Denver Museum of Art

Examinations, discipline and regular attendance determined an aspiring ballerina's life. Despite the tough regime, competition for places was fierce. This is one of Degas's most carefully drawn pastels of dancers and one of the few where Degas fully described multiple faces. The clustering of numerous figures goes against composition rules as taught at the academy. In order for the narrative of a conventional painting to be comprehensible, the identities (or roles) or persons needed to be obvious. Degas enjoyed compressing figures into single masses. In this pastel, two students occlude their chaperones, who are reduced to mere heads. One dancer adjusts her stockings, another mentally prepares for the examination. Allowing the edge of the picture to cut off parts of the figures would also have been considered bad practice in most composition classes.

The artist once made a note of subjects involving smoke that might make for good paintings. While Monet, Pissarro and Sisley worked outside and portrayed differing weather conditions, Degas was limited by his aversion to landscape topics. In the end, although he rarely painted smoke, we can view his elaborate layered window covering in his studio as his own moveable clouds and mists, altering the visible qualities of his interiors. Tulle skirts are Degas's clouds, permitting him the play of semi-transparent forms.

This picture was exhibited at the 1880 independent exhibition and sold to a private collector. Although Louisine Havemeyer later owned this pastel, it was not donated to the Metropolitan Museum. Instead, it was passed to her family and eventually to the Denver Museum of Art.

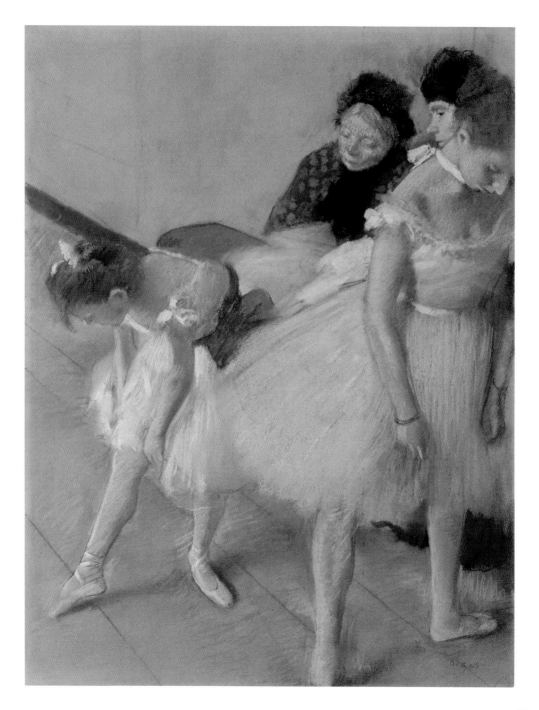

Miss La La at the Cirque Fernando, 1879

Oil on canvas
117.2 × 77.5 cm
National Gallery, London

The subject of this circus painting is Miss La La. Her name was Anna Olga Albertina Brown (1858–after 1919); she was aged twenty-one at the time Degas depicted her in a number of drawings and this painting. She was an acrobat of mixed race, half black African, half white European, who had worked in the circus since childhood. She performed with the Cirque Fernando, based in Montmartre, Paris, and was famed for her act in which she was lifted into the air whilst holding herself aloft by biting on a rope. She was the inspiration for characters in books by Edmond de Goncourt (*The Brothers Zemganno*, 1879) and Huysmans (*Against Nature*, 1884)—authors that Degas knew well.

The circus provided French artists (especially Seurat) with an array of subjects and settings which allowed them to play with dramatic compositions, strong colours and extreme artificiality. This painting is another example of Degas's persistent fascination with the working lives of women who combined manual labour and artistry. Miss La La was the subject of curiosity and admiration for supposedly combining the elegance of a woman but the strength of a man. ("A vigorous body, sinewy limbs, muscles of steel and arms of iron," as Huysmans described Miss Urania.) Women who performed publicly in the circus, opera and cafés were subjects for erotic fantasies among gentlemen; they represented prizes for bourgeois men in a similar way as courtesans were to aristocrats of pre-revolutionary France.

What seems to have caught the artist's eye in Miss La La's act was the unusual viewpoint of the figure. For an artist such as Degas—so deeply knowledgeable about classic art—a figure suspended from above and viewed from below presented an appealing topic with a noble lineage. A circus performer hanging in the air could allow a painter to depict that figure from a rarely seen angle, akin to that of a figure in a Baroque ceiling painting, yet still be unequivocally modern. Tiepolo could present angels and gods floating in the air but modern artists had no such freedom. Fragonard's famous *The Swing* (1767) presented a similarly erotically charged view of a suspended woman in a garden but presented in a very different mode. Fragonard's frisson of sexual flirtation is here replaced by the frisson of danger. Degas's sharp mind turned a fleeting circus spectacle into a way to reformulate the practice of the Old Masters. It is claimed that Degas enlisted the assistance of a master of perspective to draw the architecture accurately.

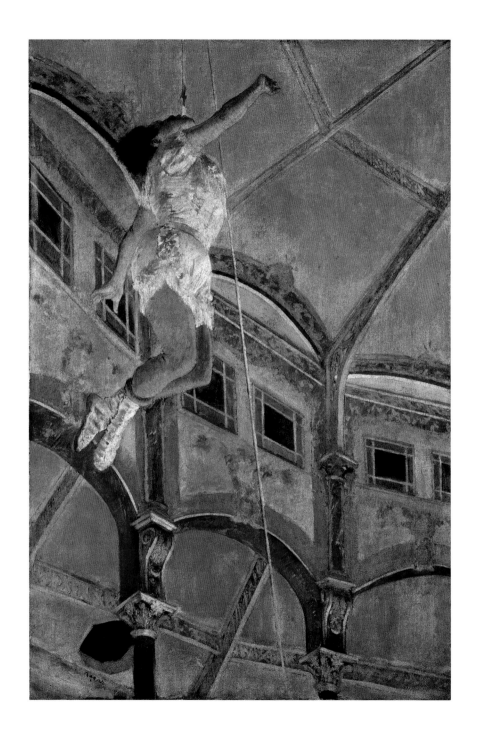

Diego Martelli, 1879

Oil on canvas
110 × 100 cm
National Gallery of Scotland, Edinburgh

Diego Martelli (1839–1896) was a Florentine writer and a supporter of Impressionism, Realism and the Barbizon School. He was friends with Federico Zandomeneghi (1841–1917), an Italian Impressionist, who was resident in Paris from 1874. Zandomeneghi worked in a style derived from Degas, whom he knew personally, and made some copies of Degas's pastel nudes. At Zandomeneghi's urging, Martelli came to Paris to see the art of the Impressionists. Martelli was staying in Paris from April 1878 to April 1879, writing newspaper reports on Impressionist art, when Degas painted his portrait.

Martelli's forceful character is captured in his aloof and thoughtful pose, with a sense of contained energy ready to burst forth. His sitting askew on the foldable stool gives an impression of impromptu informality. His pipe, inkpot and papers are to hand on the table, ready for work. Again, the subject is off-centre. Years later, Martelli wanted to buy this painting but Degas refused to sell it, claiming the critic Duranty (page 42) had disapproved of the way Degas had foreshortened Martelli's legs. Duranty was long dead by the time Martelli made his request and was the subject of another Degas portrait, drawn in pastel the same year as this one. In the Martelli and Duranty portraits, Degas included material relating to their professions, as we see in portraits from the Renaissance onwards.

Degas used the high vantage point as a means to introduce an element of dislocation. A century later, the high vantage point of a seated figure absorbed in his or her own thoughts became a favoured approach for portrait painting by Lucian Freud.

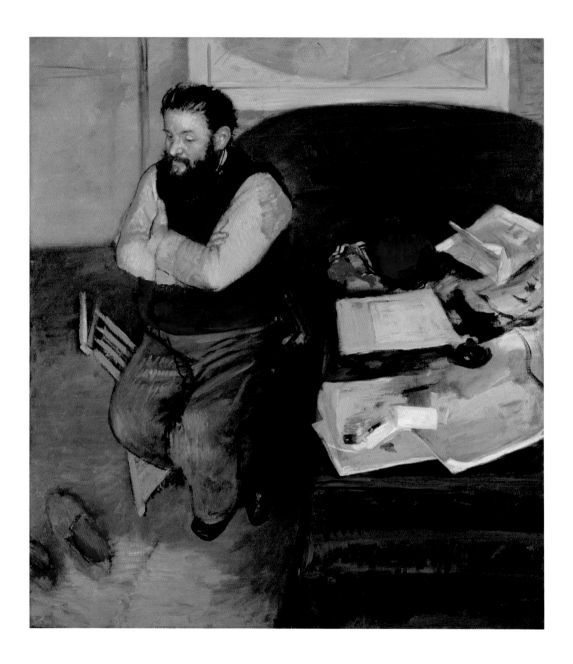

Mary Cassatt, c. 1879–84

Oil on canvas
73.3 × 60 cm
National Portrait Gallery, Smithsonian Institution, Washington DC

In an ungainly pose, Mary Cassatt leans forward, holding prints, photographs or some other material. At a late stage in the painting process, an area of white paint was applied and then roughly scraped off with a palette knife. The light patch was applied in order to separate the head from the background, bring the subject forward and give her more presence. The close-up and high vantage point, as in the portrait of Martelli, increase the oddness of this portrait. The harshness of the face is distinctly unflattering. The sitter owned this portrait, which she never offered for exhibition. In a 1913 letter to art dealer Ambroise Vollard, Cassatt expressed her opinion of the portrait. "It has artistic qualities but it is painful and depicts me as such a repugnant person, that I don't want anyone to know I posed for it. [...] The portrait is unfinished and unsigned." Vollard bought the painting from her and sold it on.

Cassatt's relationship with Degas had cooled somewhat after their journal project folded in 1880. They (indirectly) exchanged a few barbs in later years but clearly maintained respect for each other's art. For whatever reason, before her death Cassatt burned Degas's letters in her possession, as well as some works on paper by him that she considered unimportant.

Cassatt became advisor to the rich American collector Louisine Havemeyer, sending letters from Paris recommending art for her to purchase. Thus, Cassatt's support brought many of Degas's best pictures to the USA (page 48). It is notable that she did not want Havemeyer to acquire this portrait, which is further evidence of Cassatt's discomfort with it.

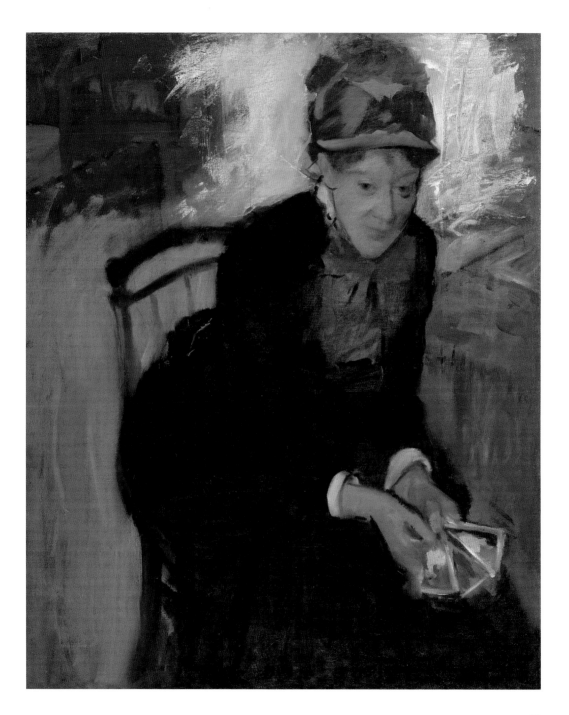

Woman Viewed from Behind (Visit to a Museum), c. 1879–85

Oil on canvas
81.3 × 75.6 cm
National Gallery of Art, Washington DC

British artist Walter Sickert visited Degas's studio at Rue Victor Massé in 1885. "Upstairs I watched him with interest one day when he was glazing a painting with a flow of varnish by means of a big flat brush. It represented a lady drifting in a picture-gallery. He said that he wanted to give the idea of that bored, and respectfully crushed and impressed absence of all sensation that women experience in front of paintings." Many experts state that—despite Degas's reknowned misanthropy—this statement seems highly unlikely, given that Degas's respect for Cassatt contradicts this deprecatory comment.

One of the most striking aspects of the painting is the disimilarity in paint handling between figure and surroundings. The woman is tightly described with precise brushwork; the environment she inhabits is depicted with broad brushstrokes, inexact modelling and great energy. This contrast does a number of things. It causes us to direct our attention to the figure; it establishes that the setting is relatively unimportant—little more than generic context; and it replicates the way we look at objects in the real world. Hold an object up in your hand. You will notice that when you focus on the object, its surroundings become fuzzy and indistinct. The human eye focuses on a subject of attention and consequently objects that are at different distances become unclear.

In Degas's time, academic painters and the Pre-Raphaelite painters described everything in their paintings equally clearly, regardless of how close, how distant and important, or how unimportant these parts were. Degas and the Impressionists were fascinated by perception and constantly experimented to see how to create the impression of an object without describing that object literally. In this masterful painting, Degas exploits our recognition of parquet flooring, heavy gilded frames and closely hung pictures as typical of art galleries, to subconsciously direct our interpretation of these boldly-handled surroundings.

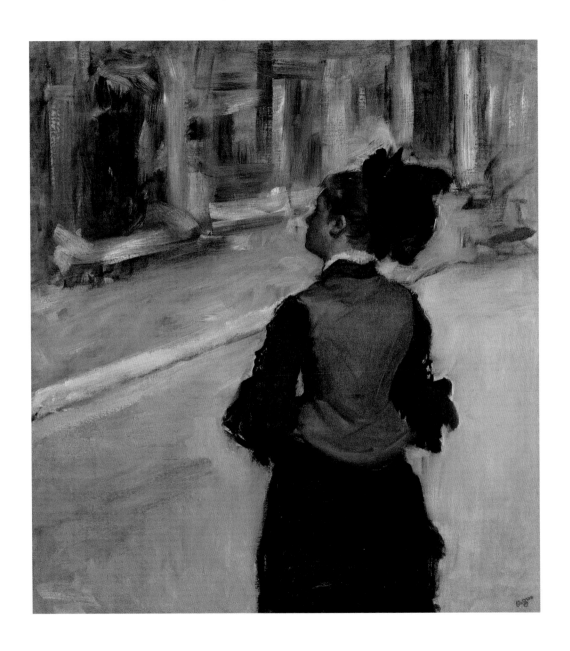

Little Dancer Aged Fourteen, c. 1878–81

Pigmented beeswax, clay, metal armature, rope, paintbrushes, human hair,
silk and linen ribbon, cotton and silk tutu, linen slippers, on wooden base
98.9 (h) x 34.7 (w) x 35.2 (d) cm (without base)
National Gallery of Art, Washington DC

The 1880 independent exhibition catalogue announced the display of a statue
of a dancer, yet the glass case in the gallery remained empty. It was not until the
exhibition the following year that Degas's sculpture finally appeared. It caused
a sensation. Visitors were "stunned and embarrassed" to see the statue of a
young dancer at two-thirds life size in a cabinet, almost a specimen in an anthro-
pological museum. The real clothes and human hair were disconcerting. Art
critic Joris-Karl Huysmans admitted "the terrifying reality of this statuette must
obviously disturb its public." Commentators suspected that during his trips to
London, Degas had visited Madame Tussauds wax museum. Coloured wax (com-
monly used for medical statuettes and in circus sideshows) had contemporary
associations which suggested it was not a suitable medium for art. The viewing
experience troubled other critics: "The pug-nosed, vicious face of this scarcely
pubescent girl, a blossoming street urchin, remains unforgettable," "most
frightfully hideous," "a juvenile monster." Writers detected traces of criminal
physiognomy in her features. Huysmans concluded, "This statuette, both refined
and barbaric in its meticulous clothing and its coloured, almost breathing, flesh,
informed by the play of the muscles, is the only genuinely modern experiment in
sculpture that I have yet encountered."

Degas used the tilted head, closed eyes and evident bodily tension to show
the dedication required of dancers. Her slender athletic physique demonstrates
the physical and dietary demands of her occupation. Even in the knowledge
that this is not real, it is disconcerting to view first hand a figure so realistic and
exhibiting stress. The model was Marie van Goethem, a working-class girl from an
immigrant Belgian family, who studied at the Opéra ballet school. She modelled
for the artist, with her mother as a chaperone, so Degas could make numerous
drawings of her from all angles (page 26). We know almost nothing about her.
There is no record of Marie's life after she was dismissed from the Opéra for
irregular attendance.

It is ironic that one of the painter's works that is best loved today is not only a
sculpture but one that provoked widespread rejection and hostility when it first
appeared.

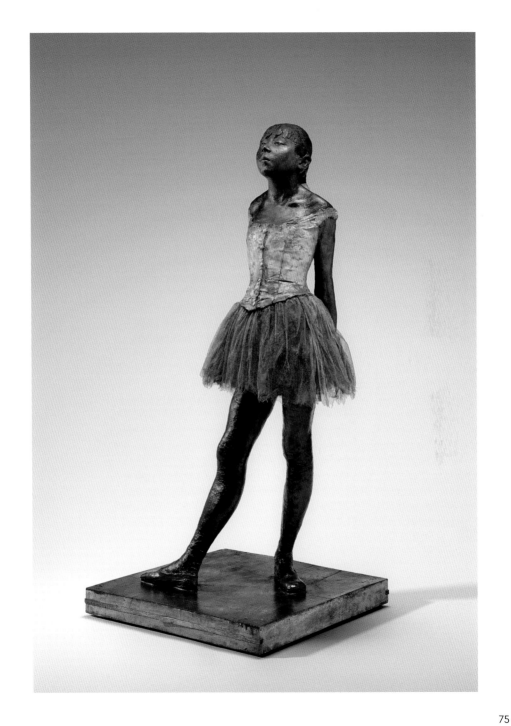

At the Milliner's, c. 1881

Pastel on paper
69.2 × 69.2 cm
Metropolitan Museum of Art, New York

The hat trade was an important industry in late nineteenth-century Europe, with hats being a prerequisite for respectable attire. Hats became status symbols, with richer customers purchasing hats of extravagant size and ostentatiousness, featuring exotic fabrics, artificial flowers and colourful feathers. The prices of hats including rare feathers could reach 500 francs at a time when female labourers earned around 3 francs per day. Degas's models were paid 6 francs per four-hour session. The demand for feathers of tropical birds became so great that it caused the near extinction of a number of species; opposition to the trade led to the establishment of wildlife conservancy organisations.

Degas produced twenty-seven identified pictures dealing with the millinery trade. They range from shop scenes to those of milliners working in private. He visited a number of shops, although we cannot identify which, to draw in sketchbooks. The most exclusive milliners were located in the IXᵉ arrondisement, in Place Vendôme and Place de l'Opéra and along the short Rue de la Paix, which ran between these squares. All were close to Degas's studio. After sketching in situ, the artist would hire models to pose in his studio in costumes or their own clothing. He had props and could arrange poses in the convenience of his studio rather than relying on memory. Unlike landscape-painter colleagues, Degas did not work on larger pictures outdoors or out of his studio.

Here, a milliner alters a hat that the customer is trying out, as the latter gazes at her reflection in a mirror which is out of the frame. In this picture, the ritual behaviour of selling goods mimics amity and affection. Degas's unfailingly sharp eye for body language allowed him to spot how the movements of a milliner resembled the actions between friends.

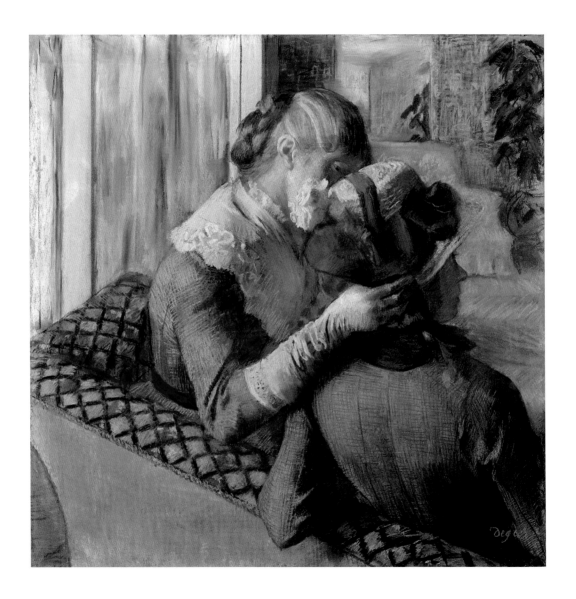

After the Bath, 1883/4

Pastel on paper
52 × 32 cm
Private collection

In a memoir published after his death, a model calling herself "Alice Michel" recalled her experience of working for Degas during 1900–1910. According to her, he could be a martinet when a model's attention wandered and she could not hold a pose. She also recalled that he could be kind and thoughtful. This pose is one that could only be held a few minutes at a time. Placing a support under the raised foot would not have been possible as that would have altered the position and shape of the flexed muscles. Degas must have observed and worked for the few minutes that the model held the pose, then worked from memory until requesting the model resume the pose.

In addition to those who sat for portraits, Degas worked with models who were dancers, actresses and professional models. There was a square in Montmartre where women gathered every morning, waiting for daily casual work with artists who would select them on the day. Degas preferred to have more regular arrangements, with particular models coming at set times on the same day every week. In one case, he requested a butcher's wife come to model. She was appalled when Degas asked her to disrobe, as she had assumed he wanted to make a portrait. Only after the artist had persuaded her husband that she was quite safe, did she relent and model nude for several drawings.

Degas's sensitivity to light caused him discomfort. Visitors to his studio noted how dim it was. He habitually draped the windows heavily with muslin and linen, adjusting the drapes to allow the minimum of light necessary for his work.

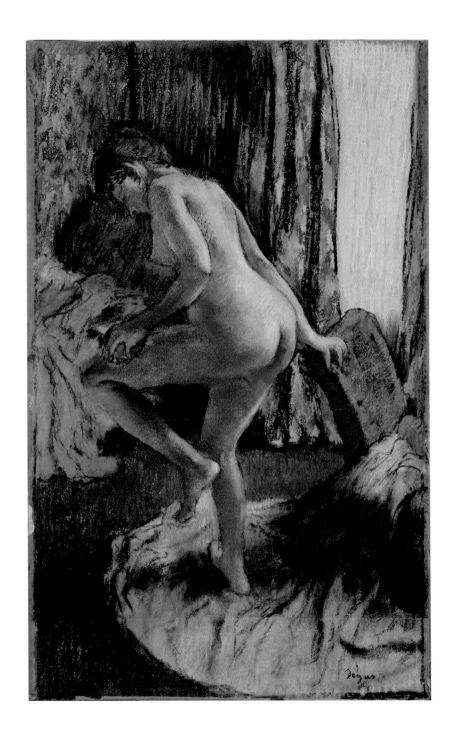

Women Ironing, c. 1884–86

Oil on canvas
76 × 81 cm
Musée d'Orsay, Paris

Social Realism was a movement in art and literature highlighting the working conditions of the poor. It included implicit social commentary regarding the fairness or otherwise of what was customarily expected of the lower class in their daily lives—activities usually overlooked by middle and upper-class gallery visitors and art collectors. Some Social Realists publicly appealed for legal and economic reform.

A related branch in painting was Naturalism, pioneered by Jules Bastien-Lepage in the late 1870s, which combined social commentary with hyper-realism. The Impressionists frequently approached the same subjects tackled by Social Realists. The waitress, washerwomen, fruitpicker, errand girl, barmaid and seller, at work and play, were common subjects for the Impressionists, who were committed to documenting modern life. An admired precursor was Courbet, whose scenes of peasants working shocked visitors to the Salon of 1850. Not all subjects were female: one of Caillebotte's best known paintings was of men scraping a wooden floor.

Degas was friendly with Pissarro, who lived for much of his life on the edge of or outside Paris and painted peasants; his sympathy with the lot of rural workers was linked to his political anarchism. Conversely, Degas, who also spent time with working people, was conservative in his politics. Degas respected the skill and stamina of labourers but that did not translate into support for political change. In this painting, we see a laundress holding a bottle of wine. Workers drank wine because it was generally safer than pump or faucet water. Interestingly enough, Caillebotte's *Floor-scrapers* (1894) also includes a bottle of wine. Only when filtrated mains water became commonplace did alcohol consumption in the workplace reduce. The interlinking influence of alcohol consumption, manual work, prostitution and moral degeneration was a topic that social reformers actively campaigned on in Degas's era.

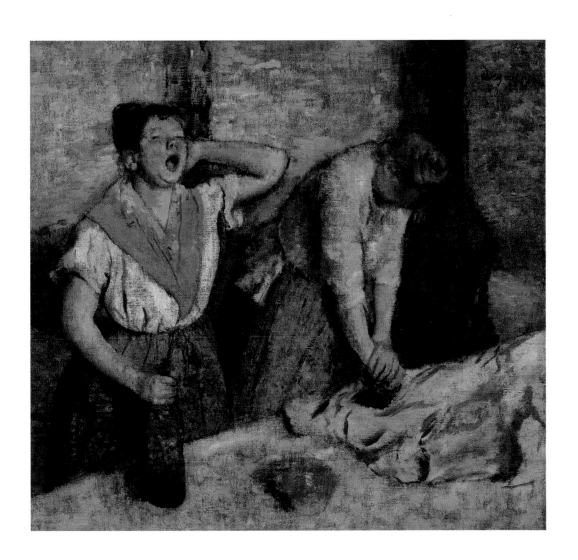

Mary Cassatt at the Louvre, 1885

Pastel over etching (with aquatint, drypoint and *crayon électrique*) on tan paper
30.5 × 12.7 cm
Art Institute of Chicago

This composition originated in 1879, when Degas was preparing prints for the *Le Jour et la Nuit* journal. One of the artists Degas was working with was Cassatt. Degas requested Cassatt act as his model for the print designs. Here Cassatt stands with her back to us, holding an umbrella and looking at paintings in the Louvre. Her slender arm extends a line along the tapering umbrella, acquiring an almost geometric clarity. Seated on a bench reading a guide is another woman, often identified as Lydia, Cassatt's sister. Yet again, we are denied a clear view of their faces. In the original sketches, the two figures were separate motifs and complete. Degas combined and overlapped the figures, setting them in a narrow upright oblong that has been made even narrower by cropping the left with a marble door jamb. Other versions of this composition involve the separation and inversion of the women. The variations were made through tracing, squaring and photographic enlargement/reduction. This is another instance of Degas taking a print as the basis for a reimagining. The starting point of the picture is a black-and-white etching printed on paper. Etched lines laid out the design; speckled aquatint added shade; drypoint provided scratched corrections. *Crayon électrique* is a form of electric drill used to engrave metalwork. Over the finished print on paper, Degas has applied pastel. This makes the picture unique and quite different from the print, although the designs of the pastel and print are identical. Degas was a gifted printmaker but his innate tendency to tinker left us with many different states (stages) of prints and few that were completed to his satisfaction. The artist was absorbed by the process; he refined his designs but showed no urge to produce a finished product that could be printed in multiple proofs (copies) and sold. There are no Degas prints that were editioned in large numbers.

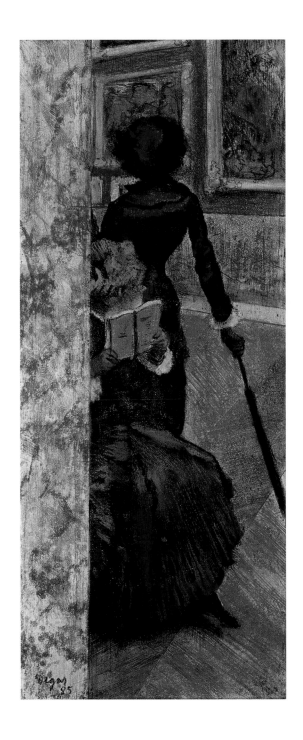

Woman Combing her Hair, c. 1885

Pastel on grey-brown paper
54 × 52.5 cm
State Hermitage Museum, St. Petersburg

Degas preferred to show the back and sides of female nudes. Full frontal nudes are very uncommon in his oeuvre. One reason for that may be related to a reluctance to show faces. Paradoxically, Degas (the gifted portraitist) rarely shows faces of figures which are not portraits. This contributes to the emotional opacity of Degas's art. Aside from the obvious comedy of the brothel monotypes, it is the ambiguity of Degas's art that hooks us. We do not know exactly who most of the figures are; we can ascertain little about their lives from what we see. There are no obvious clues or obvious narratives. Even early paintings such as *Young Spartans Exercising* (page 13), *Sulking* (page 43) and *Interior* are difficult to interpret or read emotionally. Degas does not direct us towards states of distress, awe or sentimentality. His art is as emotionally reserved as it is technically audacious. When there is beauty, it is tinged by strangeness; when there is glamour, it is undercut by irony.
Take this drawing. Is it an accurate depiction of a young woman at her toilette or is it a means for an artist to explore a solution to an idea? Can it be both? Is the presence of strongly sculptural qualities, such as full modelling of volume, visible musculature, noticeably flattened planar aspects of the back, something Degas intended or something that arose unconsciously? Aristide Maillol claimed he would start a statue by taking an abstract shape and building a figure to fit it and here Degas is on the cusp of describing forms for their own sake. This drawing balances realistic description, that informed Degas's early production, and the compulsion to explore shapes, which would drive Degas in his last period.

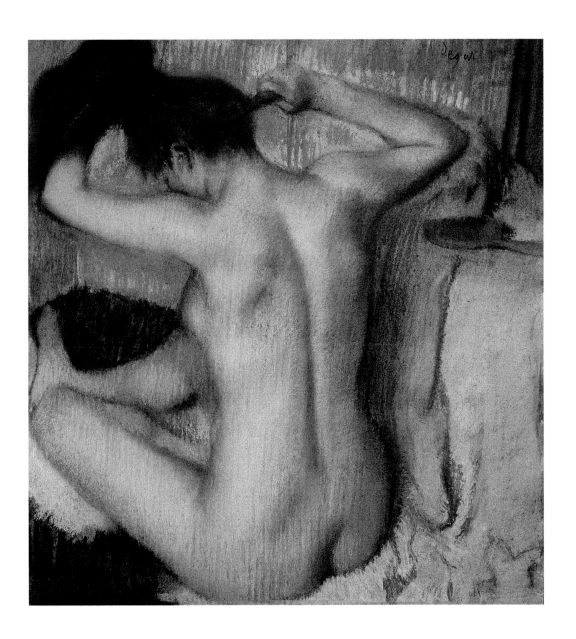

Nude Woman Drying her Foot, c. 1885/6

Pastel on card
54.3 × 52.4 cm
Musée d'Orsay, Paris

This picture is one of two drawings which were made at the same time, and which are almost the same size, of this model in roughly similar positions. In the other, she has rested her foot on the edge of a bath tub. Degas would often have a model take different poses in the same session so he could develop variants in parallel. At this period, Muybridge and Étienne-Jules Marey were making sequential photographs of dancers and athletes, demonstrating how the body moved. Degas was aware of these and developed his own ideas about placing a figure in multiple positions in one picture.

The sight of a woman engaged so unselfconsciously in the private activity of attending to her body, elicited accusations of misogyny. After all, what kind of cruel, base individual would show women in such an undignified manner? The accusation of prejudice is somewhat unfair. Consider, *Lo Spinario*, the Greek statue of a boy removing a thorn from his foot—a piece showing a boy acting in a manner similar to the subject of this picture. Degas saw versions of the piece in Rome and Florence and at the Louvre. As a keen student of body language, Degas was applying his lessons to men and women alike, though it was women he painted unclothed. Degas admitted that he wanted to show "the human animal taking care of herself; a cat licking herself," and "I want to look through the keyhole". His aim was to see the unguarded truth of a person's life—the dancer slumped with tiredness, the laundress yawning, the woman climbing out of the tub. Just as Social Realists exposed living and working conditions, so Degas wanted to document the most essential part of existence—taking care of one's own body. Degas was the most complex of individuals; that is why he produced nudes that are clinically unsparing yet tenderly sympathetic, simultaneously awkward and beautiful. Charles Baudelaire wrote the following art criticism: "The Beautiful is always strange. [...] It always contains a touch of strangeness, of simple, unpremeditated and unconscious strangeness, and that it is this touch of strangeness that gives it its particular quality as Beauty."

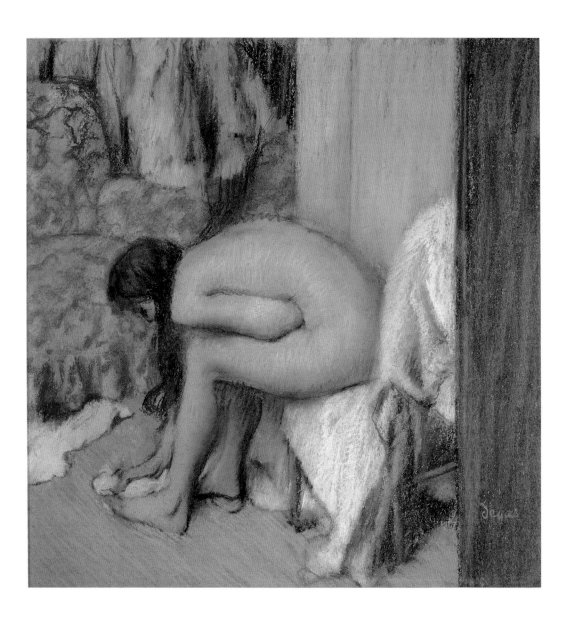

The Tub, c. 1885/6

Pastel on paper
70 × 70 cm
Hill-Stead Museum of Art, Farmington, Connecticut

In this timeless and quintessential Degas nude, we can see that the artist was intent on describing anatomy in the position it most appealed to him. The back is as complex and various as a landscape. The precise modelling of the woman's pale back is set off against the flat but colourful carpet and the dim blue of the curtains. The white sheet of towel throws the dark rim of the tub into relief. This pastel and *The Tub* (page 35) are part of a series featuring the same model and props. A further one is in the Metropolitan Museum of Art and another is in Hiroshima. It is possible that two other pastels of around this time are of the same model. Certainly, the auburn hair and physique look similar. Degas liked to work with certain models regularly over several months.

The accurate physiques of women found in Degas's art came as a shock to art lovers accustomed to the idealised anatomies of Cabanel (page 14) and others. Academic painters altered physiques, overlooked imperfections and sought to imitate the flawlessness of marble statues. Body hair was very rarely included in academic art, as it was considered vulgar and animalistic. In 1908, Georges Grappe wrote about Degas's models, "An artist is free to choose his subjects and he will always find more to interest him in models on whom life has set its mark, and who are scarred by vice and disfigured by the pursuit of a profession, or by the usages of society. Countenances that bear the traces of our modern existence present a more interesting character to portray than the physiognomy of a professional beauty. And it cannot be denied that they are more frequent in our civilisation." Whatever their reasoning, critics identified the models as lower class. This may simply be because most models were poor women who modelled for money. It is a striking feature of the art criticism of the time how frequently matters of class and status are raised.

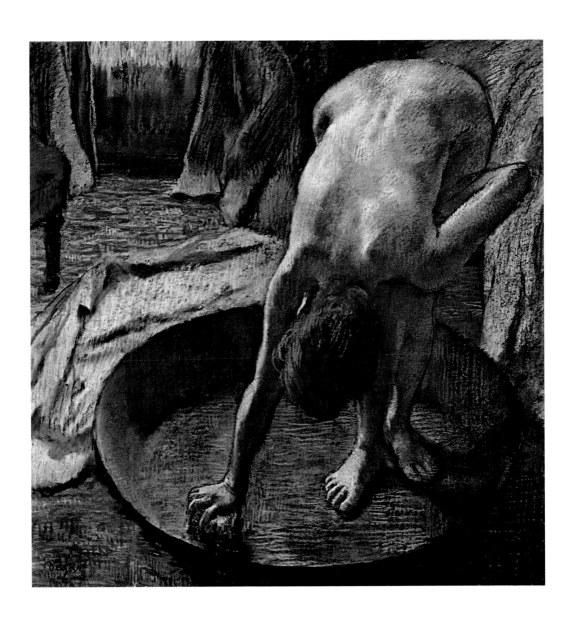

The Tub, 1886

Pastel on card
60 × 83 cm
Musée d'Orsay, Paris

The strong responses of contemporaries to the bathers can be judged by this passage from the art critic Félix Fénéon. It was published in 1886, the year this pastel was exhibited at the last independent exhibition. "Concerning M. Degas. Women squatting in their bathtubs fill them to the brim with their proliferating curves: one, whose chins reach her bosom, is scouring her neck. [...] It is in cramped space in dark, furnished hotel rooms, that these bodies, bruised by a rich patina of copulation, childbirth and illness, stretch their limbs or scrape their skin." It hardly seems that Degas is one to degrade the unclothed body, but rather critics, acting as guardians of public propriety and decorum, who are displaying intense distaste. Fénéon admits that "in M. Degas's work as in no other, human flesh lives an expressive life of its own"—although he probably did not mean it as a compliment.

The handle of the hairbrush and that of the coffee pot jutting over the edge of the table or shelf creates a sense of depth. Still-life painters from the Dutch Golden Age onwards used foreshortening and projection of objects to display their virtuosity and emphasise pictorial depth. In some cases it amounted to *trompe-l'œil*. The inclusion of the coffee pot, hairbrush, water jug, scissors and another item, that could be of cloth or fur, add a touch of verity. Significantly, Degas did not make still-lifes, despite his evident competence. Like his heroes Jacques-Louis David and Ingres, Degas too found landscapes and still-lifes exercised no hold over his imagination. Degas is the heir to those great masters of the past because he turned his favoured motif—the bathing woman—into a subject of iconic images combining grandeur and sensitivity in art that is both memorable and brilliantly executed. When one thinks of the female nude, one of the first images that comes to mind are pictures such as *The Tub*.

The paintings of Bonnard directly extend Degas's bathers series with their domestic intimacy, chromatic complexity and compartmentalisation of picture surfaces. Bonnard's painting of a nude in a tub at the Royal Museum of Fine Art, Brussels, is a clear example of this.

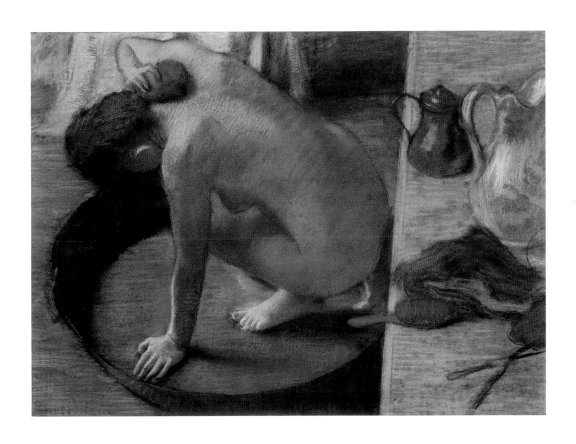

Jockeys in the Rain, 1886

Pastel on tracing paper
47 × 65 cm
Burrell Collection, Glasgow

Horses and riders line up for a race in the rain. Degas rarely had a chance to experiment with weather effects that his landscape-painter colleagues so famously explored. Dashes of rain are pale blue; the turf is composed of scribbled light sage and slashes of pale blue over olive and greenish tan. The glossy coats of the horses are burnt umber and maroon, with bluish-grey highlights.

Degas collected props and costumes for his work, including a model horse, on which he could position riders in his studio. It allowed him to record the position and viewpoint of riders in a controlled environment. This explains why many preparatory drawings and painted sketches exist that are so detailed.

The support for the drawing is tracing paper or *papier calque*, a vegetable-fibre paper made transparent through resins and oils, which is used to make tracings. Degas not only used it to transfer designs but as the ground for completed drawings, a practice discouraged by expert advice. Expert pastelists recommend heavy, textured papers as the best supports because these surfaces offer most grip for pastel particles. Degas was evidently pleased by the feel of drawing on slippery tracing paper, something that outweighed the difficulty of building multiple layers of pastel on smooth paper. Another disadvantage of *papier calque* is that it ages rapidly, turning brown and brittle. Degas's drawings on tinted wood-and-cotton-pulp paper have also altered in appearance since he made them. Aniline dyes, discovered in 1856, that are used to colour paper are often impermanent; papers that were originally blue, green and pink have turned grey. This can be seen when picture mounts have been removed to reveal the original colours protected from ultraviolet rays. Some of Degas's paint and pastel pigments have also faded.

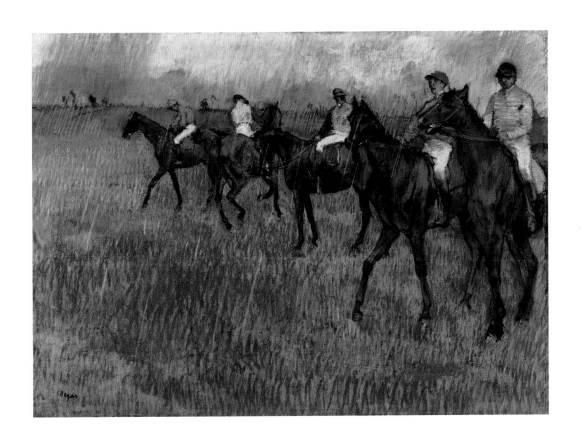

Female Nude Having her Hair Combed, c. 1886–88

Pastel on card
76 × 60.6 cm
Metropolitan Museum of Art, New York

This is one of the most complete and approachable of Degas's later nudes. There is no acrobatic pose, no obscured face, no truncated limbs. The completely accurate anatomical proportions underline Degas's confident handling of the subject. His great experience in portraying the unclothed body came from years of specialisation, and the regular work with nude models meant that he became an expert in depicting skin, hair and the various aspects of the figure that less consumate artists summarise. Artists develop their skills in depicting foliage, silks, flowers, animal pelts and the lustre of fruit. The more skill they accrue, the more they wish to outdo themselves. They also sharpen their perceptiveness. It clearly did not escape Degas's attention the way the model's thumb pressed into the swell of her flank, mimicking the way buttons secure upholstery on the chaise longue upon which she is seated.

By cropping the head and shoulders of the maid, and drawing her blouse as tonally indistinguishable from the background, the artist leads us to consider the seated woman in isolation. Degas sometimes reversed such solutions. The Ny Carlsberg Glyptotek in Copenhagen houses the Degas pastel *Toilette after the Bath* (1888/9), where the subject is a maid holding up a towel; her mistress's figure is confined to a sliver at the side of the composition.

Although Degas was well known in his lifetime for his quick wit and cutting com-ments, he tended to be attentive and considerate towards models and servants. He had a good relationship with his housekeeper Zoé Closier and photographed himself with her.

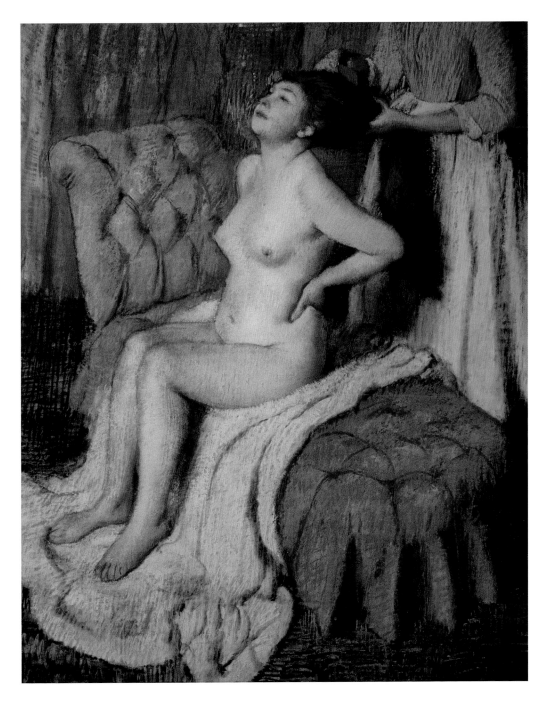

In Front of the Mirror, 1889

Pastel on paper
49 × 64 cm
Hamburger Kunsthalle, Hamburg

This beautiful image is like a scene from a story by Gustave Flaubert or Guy de Maupassant. The woman fixes her hat with hat pins as light glances across her shoulders. Traditionally, pale skin was considered ladylike and aristocratic; tans were associated with country folk and labourers who had to work outdoors. There are essentially only three colours in this picture: cobalt blue, russet and white. The warm and cool colours balance and complement each other, with white tempering them.

In this picture, we get a glimpse of an ordinary life that will still be familiar to many, set in a time of widening horizons. Industrialisation and urbanisation made Paris the centre of the couture trade. Shops, department stores and arcades flourished as sites of desire for women seeking to express their taste and refinement through material consumption. Commercial production made luxury goods affordable. Advertising reached new levels of sophistication in newspapers and fashion journals; colour posters turned the city into a riotous explosion of artificial flowers, ready to be plucked by discerning ladies. Women's dress reform, property rights, financial independence and political enfranchisement were hotly debated. Women escaping drudgery and duty only to encounter new temptations in the city was the stuff of sensational stories of crime and divorce in the newspapers; it was also fodder for novelists. Art critics were forever debating the moral status of Degas's women, reflecting Parisian society's unease over the uncertain demarcations between extra-marital affairs, concubinage, transactional sex and prostitution.

Previously dated 1885/6, the latest expert consensus is that this pastel was created in 1889. The similarity of the objects on the dresser to those in The Tub (page 91) maybe suggested the earlier date. Dating Degas's work is often difficult as he rarely dated it and retained pictures for years before exhibiting or selling them.

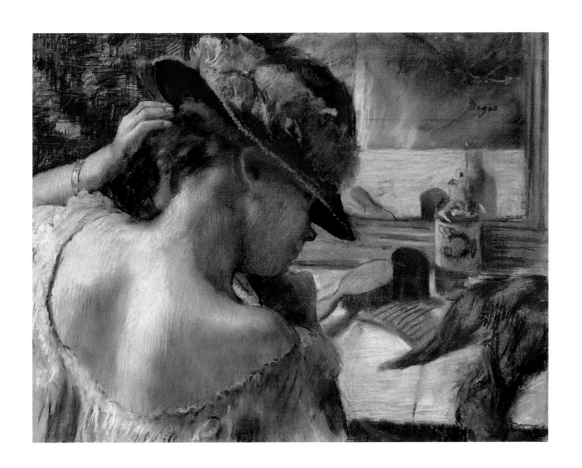

Coastal Landscape, c. 1892

Pastel over monotype on tan paper
46 × 55 cm
Galerie Jan Krugier, Geneva

In November 1892 Degas held a rare solo exhibition at Paul Durand-Ruel's gallery. What was even more notable was that this master of the figure was displaying monotypes of landscapes. This was an oddity because, as acquaintances noted, Degas was critical of contemporary landscape painting. He made small landscape sketches in oil on paper of sights in Italy during his youth, but rarely afterwards. The prints were in colour and often close to abstraction, with the landscape reduced to blurred and speckled bands of pasture and hill, some with distant chimneys issuing smoke. Some prints were retouched with pastel.

In this picture, a monotype has been completely covered by a pastel. Reading from left to right, we see steep slopes of raised thighs descending to the gentle swell of a belly and then conical breasts; finally, the vertical cliff of sandstone is the long russet a woman's hair tumbling down. It is a tactile work, inviting us to conflate the familiar shape of a woman's body and the texture of turf and sandstone. We can think of this picture as not only a classic example of anthropomorphism, where the non-human is given attributes of a person, but also a form of synesthesia, when the mind confuses sensory inputs. We experience the sensation of touch whilst only looking.

This picture is a riposte to landscape painters, maybe to Monet in particular, whom Degas considered a rival. Degas disdained *plein-air* painters, jesting that they should be driven away by gendarmes. In this picture, Degas was teasing landscapists by entering their territory and subverting it by making a landscape out of the human form. Not least, he was doing it indoors because monotypes must be made in the studio in proximity to an etching press. Wittily, Degas was suggesting in this picture that the nude was a branch of art so flexible and compelling that it could be whatever a gifted artist wanted it to be.

Breakfast after the Bath, c. 1895

Pastel on paper
121 × 92 cm
Private collection

Degas returned to this subject many times over his last decades. This version is the most fully realised and rich in colour. The nude woman and her clothed attendant is a subject that goes back to antiquity and was a particular favourite of painters from the Renaissance, Baroque and Rococco periods. Manet reprised the combination in his *Olympia* (page 15), which itself was taken from two paintings of Venus by Giorgione and Titian.

Domestic servants were very common until the outbreak of the Great War in 1914. Going into domestic service was a slightly preferable occupation to factory work, the garment trade and other menial jobs. The presence of the servant does not necessarily indicate that the bathing woman is of anything higher than modest status. This scene might depict one of the numerous actresses and singers in Paris who lived in apartments paid for by their lovers. It is possible that Degas had in mind one of the many contemporary novels that feature mistresses or concubines. We cannot pin down instances of Degas using literature as a source. We know that he read widely and was friends with authors but he did not provide narrative titles to "explain" pictures; in this respect, he was like the other Impressionists. Note the high vantage point. This almost certainly comes about through the placement of the motifs rather than Degas working from life with two models. The scene has been built on the sheet with independent motifs rather than arranged with models posed in the studio together. The high vantage point is characteristic of Japanese prints.

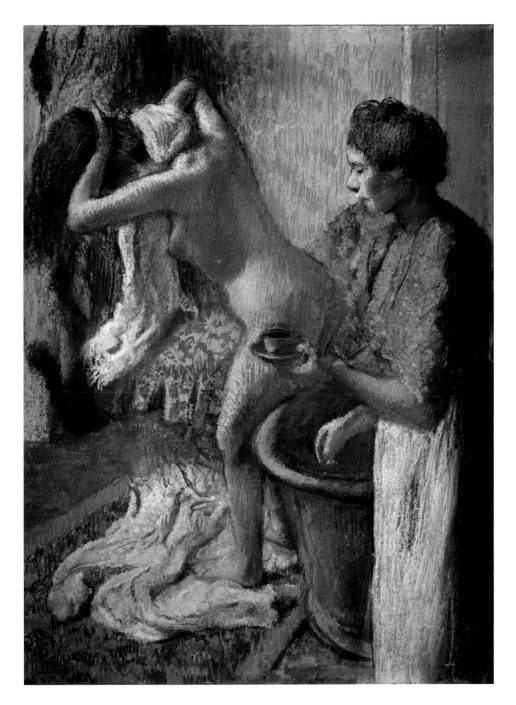

The Morning Bath, c. 1895

Pastel on paper
66.8 × 45 cm
Art Institute of Chicago

It is rare that the title of the picture comes directly from the artist himself. But here it does. Degas did not pay much attention to titles and most of his art was titled by cataloguers after his death in bare descriptive terms. The narrative can be easily understood. A woman enters a bath; in the foreground is an unmade bed and the bedroom is filled with cool morning light.

The bather, in this beautiful and chromatically cool pastel, is in a dynamic pose. The harmonies of aqueaous hues of blue and green are heightened by the pale pink of the body. The blue light reflected from the curtain is caught on the woman's hip, flank and breast; touches of reflected green from the wallpaper appear on the left arm, the back and other parts. The capacity of pale skin over subcutaneous fat to catch reflected light transforms the expressiveness of the nude figure. Artists such as Rubens and Delacroix used reflected light and brushstrokes of contrasting colours to engender vigour and excitement to painting of unclothed flesh.

Many artists have been excited by the drama and tragedy of fragments of ancient statues. Degas spent many hours copying antiquities in Italy in his youth and visited the Louvre all his life. In his mature art, Degas found a way to capture a certain movement or shape by reducing the human figure. We often encounter limbs obscured, heads lowered, faces averted, bodies reduced to a sliver by the edge of a screen. The plastic potential of the body was also explored by Auguste Rodin in this era through his removal of limbs and heads from some of his realistic statues, turning them into strangely powerful primitive avatars. Rodin literally sawed off parts of plaster casts, whereas Degas used screens, curtains, furniture and towels— as well as the position of the body itself—to conceal parts of the figure. The artists shared similar interests but used different approaches to achieve the same goal. In his reduced human forms, Degas shows us the body in a startlingly fresh way, filling us with wonder.

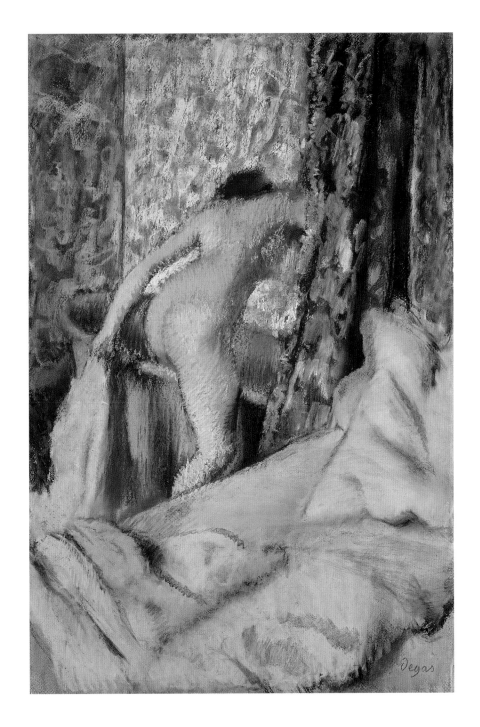

Combing the Hair (La Coiffure), c. 1896

Oil on canvas
124 × 150 cm
National Gallery, London

In the late 1890s, colour became increasingly important to Degas. As his eyesight deterioated, he became incapable of the delicate shading and observation of detail that was characteristic of his early production. He sought ever stronger colours and more striking contrasts. In this painting, a fiery brick-red suffuses the whole painting surface. Unlike other earlier pictures by Degas, there is no cool colour to balance it. The picture plane is shallow; we have no way of judging the dimensions of the room these figures occupy. Modelling of space and figures, detail and individual identities of the figures are unimportant. We do not read this paint, we experience it.

When Degas was young, he emulated Renaissance and Neoclassical artists. In Rome, Gustave Moreau introduced Degas to the power of Delacroix's Romanticism in 1858/9. Here Degas abandons himself to the sensuousness and emotionality of Romanticism. Is this a hint of his experience of Tangier in 1889? There are no other discernible traces of this journey in Degas's art.

Combing the Hair (La Coiffure) became a touchstone for artists of the following generations, especially Henri Matisse (1869–1954), whose The Dessert: Harmony in Red (1908) and Red Studio (1911) use motifs against a strong red background. Matisse was actually studying under Moreau when Degas was painting Combing the Hair. Degas's decision to pare down everything to its essence, and use the power of colour as the primary means of directing the viewer's experience, was an inspiration for Modernists of the following century, including the Fauve painters, Robert Delauney, Wassily Kandinsky, Mark Rothko, Robert Motherwell and others.

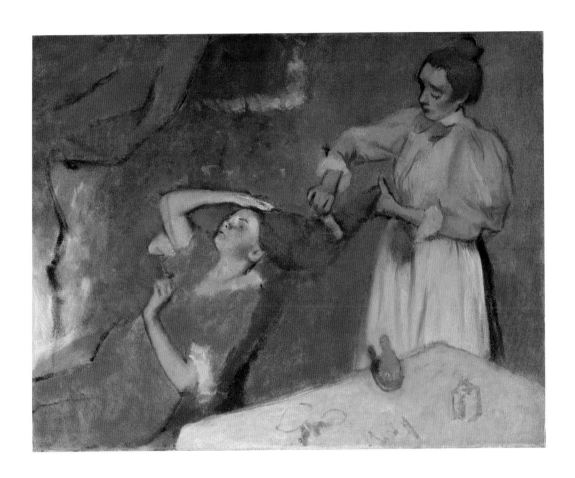

Blue Dancers, c. 1898

Pastel on paper
60 × 67 cm
Pushkin State Museum of Fine Arts, Moscow

The dim overhead lighting is what we would expect to see when observing dancers in the wings of the stage or waiting behind a curtain. It was also lighting identical to that in Degas's studio. Degas took a number of photographs of a dancer in stage costume under a skylight, which he drew repeatedly before composing this pastel, including multiple poses of the same model. Degas used to say "Make a drawing, begin it again, trace it; begin it again, and trace it again." Source photographs for this pastel exist. This is effectively a multiple-time-lapse photograph brought to life through colour and touch. Degas has drenched the picture in scintillating pale blue, violet and green enlivened by touches of ochre. The pale skins are suffused with the blue light that is reflecting off their dresses.

In the last pastels and paintings, Degas detached himself from Realism and became increasingly attached to the nude and the dancer isolated from their settings and from any literal narrative. Settings became less specific, more generalised. He submerges the subject and the viewer in a sumptuous play of colour and pattern. The last pictures are practically airless. The picture plane becomes so shallow it is almost flat and we cannot separate figure from background; bodices and tutus dissolve into scenery. There is a noticeable shift from the 1870s, when dancing was an activity to be performed in a crowded studio or on the stage, in the presence of an audience, to the 1890s, when dancers become detached from viewers and sur-roundings. Even though the subjects and motifs remained constant, Degas's social isolation in his last decades seems reflected in the content of his art.

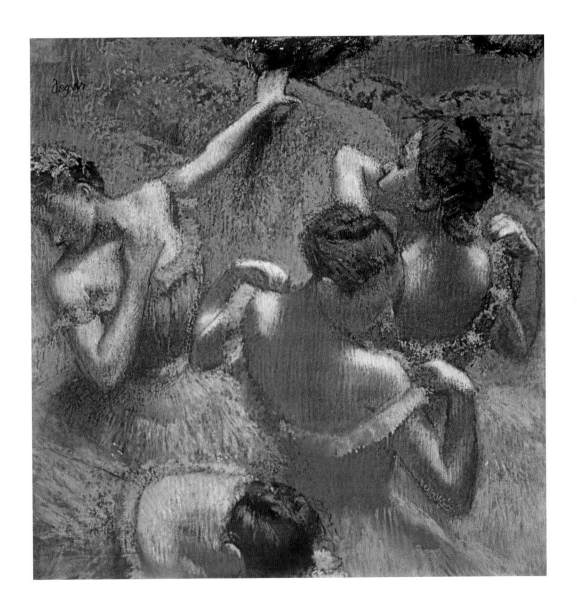

Russian Dancers, c. 1899

Pastel on paper
45 × 67 cm
Private collection, Canada

Commonly described as Russian, the costumes of these dancers have recently been identified as Ukrainian. The flowers are also typical of Ukrainian (not Russian) national folk custom. These Ukrainians must have resigned themselves to being misidentified due to a general ignorance about their nation. The heaviness and looseness of the clothing is the polar opposite of the minimal specialised costumes of French ballet. The earthiness of figures, distinctive clothing and variety in dance steps (and music) must have added to their appeal for the artist.

Julie Manet, daughter of Berthe Morisot, niece of Manet, described visiting Degas in July 1899. Degas commented on "orgies of colour that I am making at the moment" and showed her his series of "Russian" dancer pictures. The eruption of very strong colours has been closely associated to Degas's failing eyesight. Quite how badly his vision was fading is unclear. Some close to him noted that he never became entirely blind and in 1914 he visited an exhibition of Cassatt's art. Art critics have detected elements common to the late styles of artists who reach old age: loose handling, strong colour, simplified forms, reduced modelling, more abstract approach to composition. The old-age style has been characterised as a freeing of inhibition, greater confidence, pursuit of artistic freedom and independence from expectations of critics and collectors. Potential physiological causes that have been given include deteriorating eyesight (including short sightedness and cataracts), manual tremor, arthritis, loss of dexterity and lessening of stamina. Artists considered to have had a late style include Titian, Monet, Rembrandt, Picasso, Renoir and Degas. Although we should not draw too close a correlation between art and physical ailments, it is undoubted that Degas's failing eyesight contributed to his late style, with its heavily worked contours, strong colours, planar qualities and diminished detail.

Just as the visit of Cambodian dancers to Paris in 1906 inspired an elderly Rodin to create a group of unique watercolours, so these Ukrainian dancers prompted Degas—master of Parisian ballet art—to achieve works of new intensity just as his capacities were faltering.

FURTHER READING

Barbour, Daphne and Quillen Lomax, Suzanne, *Facture: Conservation, Science, Art History. Volume 3: Degas*, Washington DC/New Haven, 2017

Boggs, Jean Sutherland and Maheux, Anne, *Degas Pastels*, London/New York, 1992

Brettell, Richard R. and Fold McCullagh, Suzanne, *Degas in the Art Institute of Chicago*, Chicago/New York, 1984

Brown, Kathryn, *Perspectives on Degas*, London/New York, 2017

Clausen Pedersen, Line, *Degas' Method*, Copenhagen, 2013

Gordon, Robert and Forge, Andrew, *Degas*, New York, 1988

Hamilton, Vivien, *Drawn in Colour: Degas From the Burrell Collection*, London, 2017

Laumonier, Marie-Ange, *Degas*, Paris/Ottawa/New York, 1988

Loyrette, Henri, *Degas at the Opéra*, Paris/Washington DC, 2020

Michel, Alice, *Degas and His Model*, New York, 2017

Moore, George and Sickert, Walter, *Memories of Degas*, London, 2020

Munro, Jane, *Degas: A Passion for Perfection*, New Haven/London/Cambridge, 2017

Reff, Theodore, *Degas: The Artist's Mind*, New York, 1976

Reff, Theodore (ed), *The Letters of Edgar Degas*, Paris, 2020

Schachert, Lillian, *Edgar Degas: Dancers and Nudes*, Munich, 1997

Welsh Reed, Sue and Stern Shapiro, Barbara, *Edgar Degas: The Painter as Printmaker*, Boston, 1984

PHOTO CREDITS

akg-images: 8–9, 11, 20, 26, 32–33, 38–39, 45, 49, 57, 67, 71, 75, 91, 99, 103, 107, 109.

akg-images / Album: Cover, 18, 19, 27, 65.

akg-images / CDA / Guillemot: 35.

akg-images / André Held: 95.

akg-images / Laurent Lecat: 28, 41, 81.

akg-images / Erich Lessing: 13, 16–17, 23, 61, 87, 101.

Bridgeman Images: 12, 14, 15, 24, 31, 34, 36, 37, 47, 51, 55, 59, 63, 69, 73, 77, 83, 85, 93.

Heritage Images / Fine Art Images / akg-images: 77, 89.

Heritage Images / Heritage Art / akg-images: 43.

Heritage-Images / The Print Collector / akg-images: 53.

The National Gallery, London / akg-images: 105.